# A HISTORY OF

# SALEM

## C O U N T Y,

# NEW JERSEY

*Enjoy your trip back into history*

*Charles H. Harrison*

*8/3/11*

# A HISTORY OF

# SALEM
## COUNTY,
# NEW JERSEY

### Tomatoes and TNT

### CHARLES HARRISON

Charleston — London

THE
Hi**st**ory
PRESS

Published by The History Press
Charleston, SC 29403
www.historypress.net

*Cover images:* Men in rolling machines courtesy of Dupont Chambers Works; barn and man/horse courtesy of the *Elmer Times;* tomato can label courtesy of Salem County Historical Society.

*All internal images, unless otherwise noted, are part of the author's collection.*

First published 2011

Manufactured in the United States
ISBN 978.1.60949.238.0

Library of Congress Cataloging-in-Publication Data

Harrison, Charles Hampton, 1932-
A history of Salem County, New Jersey : tomatoes and TNT / Charles
Harrison.
p. cm.
Includes bibliographical references.
ISBN 978-1-60949-238-0
1. Salem County (N.J.)--History. 2. Salem County (N.J.)--Biography. 3.
Salem County (N.J.)--Economic conditions. I. Title.
F142.S2H36 2011
974.9'91--dc23
2011019354

# CONTENTS

# INTRODUCTION

S alem is the prime agricultural county in New Jersey and home to one of the world's great industries, a rare dichotomy in the United States. The county came close to not earning either accolade.

By the second decade of the nineteenth century, Salem County farmers were running out of productive land. As one writer put it, "[They] could find no more fields to ruin between 1810 and 1850. So they packed their families and their few possessions in wagons and went west, where virgin lands offered an opportunity for even the most wasteful."

In the last decade of the nineteenth century, E.I. duPont de Nemours and Company might not have relocated its gunpowder works onto two hundred acres lining the east bank of the Delaware River, owned by the son of Thomas Carney and Colonel Robert G. Johnson, if the company had not run out of buildings to accidentally blow up on the family's estate overlooking the Brandywine River in Delaware.

This book recounts how the descendents of Swedish, Dutch and English farming families who remained on the land discovered how they could make the depleted soil super rich again and productive beyond anyone's expectations or dreams; it also tells how exceptionally brilliant scientists and hundreds of thousands of workers created products that have changed for the better how millions of lives have been and are even now lived.

But that's not all. The book also describes how agriculture in Salem County—in all of New Jersey—has been transformed in the twenty-first century as people's dreams and needs have changed, and while DuPont

remains a major force in Salem County and the world, other county industries have and still play a significant role in this country and abroad. For example, Anchor Glass Container Corporation continues an industry that was commenced in the county in 1739 by Caspar Wistar.

Much of the history is told by the people who lived it or their descendents. For example, both American and British officers, in their own words, tell how and why they came to Salem County during the American Revolution looking for food and other necessary supplies for their armies and what rather momentous events resulted. Present-day landowners recall how family members, centuries ago, enabled both agriculture and industry to prosper.

I first wrote about Salem County nearly a quarter century ago. I'm pleased that this book offers new sources, new stories and new scenes.

CHAPTER 1

# REVERSE AND FAST FORWARD

S o, you plant seeds and young shoots in the spring, spend summer days down the shore, come home in time to harvest what you planted in the spring, maybe hunt deer or become reacquainted with a busy life and then perhaps spend time cozying by a wood (or propane) fire. That's also pretty much how the typical Lenape Indian family living in a bark-covered hut situated high on the bank of a Salem County waterway divided its time four hundred years ago.

The twenty-first century's answer to long-distance runners and smoke signals—the Internet—tells today's gardener-farmer how to grow pole beans: "Make a small mound of soil that is about 6 inches in diameter and 3 inches tall at the base of each pole. Train the vines up the poles." It should perhaps come as no surprise that Lenape women who were responsible for planting and harvesting trained their daughters to grow their beans in pretty much the same way. Of course, they might have used a deer antler to cultivate their crop.

The Lenape—or Delaware—Indians did their living, working, playing and dying on the same 338 square miles and 216,320 acres of the inner coastal plain that now compose Salem County. Lenape families lacked any modern means for analyzing and testing the soil in which they planted their beans, corn, pumpkins and bad tobacco. Today's scientists can identify nearly one hundred different soil types in the county, but they are included in two general classifications: silty soil, which covers about half the county, and sandy soil, which—you guessed it—covers the other half. The Salem

County Agriculture Development Board identifies these four agricultural soil types in the county:

| | |
|---|---|
| Prime farmland soils | 39% |
| Soils of statewide importance | 20% |
| Farmland soils of unique importance | 15% |
| Farmland soils of local importance | 2% |

Soils of statewide importance, if properly cared for, can "produce yields as high as prime farmland soils," states the development board, and farmland soils of unique and local importance are capable of producing "high value food, fiber or horticultural crops."

Grace Beckett, who traced the history of southern New Jersey agriculture in a 1957 thesis for New Jersey State Teachers College at Glassboro, described various classifications of soils and then went on to point out simply that "the Indians found these varieties in the soil [and] selected the well-drained and fertile areas for their corn fields."

## No Gentlemen Farmers

As previously mentioned, the Lenape farmer was a woman—a squaw. Her man's contribution to the family farm—perhaps more akin to today's large backyard garden—was to prepare the land for planting. Lacking any modern tools for cutting down trees and tilling the soil, the Lenape man girdled trees—stripped off bark—that caused the trees to lose their leaves and eventually to die. The leaveless trees, of course, permitted more sunlight to nourish new growth.

According to Ms. Becket, "After the girdling was done, the man went fishing, followed trails, or just sat in the shade of an old oak tree while the squaw went on with the farming." Presumably, the man was smart enough to sit under a tree that he hadn't girdled too many moons ago. If he went fishing in one of the local rivers or streams, he might catch freshwater herring. If so, his wife, perhaps using the deer antler, would dig holes in the mounds where the corn was planted and insert pieces of herring. The term fertilizer was not in her vocabulary, and no learned agent of the Rutgers Agricultural Extension Service was on hand to advise, but the Lenape squaw discovered on her own that decaying fish and leaf mold, when added to her garden,

resulted in a harvest that put to shame the crops grown in the garden tended by the squaw downstream.

When the fish heads and leaf mold seemed to no longer help nourish the crops to which they had become accustomed, the Lenape women decided their gardens were worn out, and they tilled other land. Over time, they moved farther and farther from their homes—their village.

"It may come as a surprise to the reader," wrote C.A. Weslager, "to learn that white women taken captive by the Delaware Indians in warfare often refused to be rescued after they had become members of an Indian community because they did not want to return to the subordination accorded women in colonial society."

## SUCCOTASH ANYONE?

In later centuries and on other land, tobacco would become a major and profitable crop, and in a still later century, it would become a major cause of cancer and other ailments. In the early years of the seventeenth century on the inner coastal plain, the tobacco grown by Lenape women really wasn't worth chewing or smoking. But if the squaws couldn't grow good tobacco, they could raise very good corn, and they found a variety of ways to prepare it for eating by their family.

Weslager wrote:

> *The Delawares were a cornfed people, and corn was prepared in a variety of ways, some of which were imitated by white settlers and are still in use in our modern society. Corn on the cob was roasted in the hot ashes without removing husks; it was also boiled in water with the husks in place. The kernels, removed from the cob, were mixed with beans to make succotash.*

Weslager went on to point out that cornmeal often was mixed with meat or fish to produce a pottage. "A favorite with Indian children was a confection consisting of maple syrup mixed with corn meal [*sic*]."

When the corn was knee high, Lenape families closed down their bark-covered abodes and took the nearest and most direct trail to the seashore. Of course, being down on the shore wasn't just fun and games and sand castles. A lot of time was spent by adult members of the family gathering up oysters and clams and spearing fish, all of which were dried in the sun.

Lenape families instinctively knew when it was time to go home, back to their villages on the banks of streams and small rivers that followed the setting sun and drained into the wide river, which made a very sharp turn before rolling south to the great ocean. Grace Beckett described the homecoming beautifully:

> The squaws packed some large shells to use for cooking utensils with the trappings that they had brought to the summer camp. They put dried oysters into pouches, made strings of dried fish, and tied wild fowl into bundles. When they had gathered together all that the family could carry, they were ready to set out for home.

No one knows for sure how many Lenape families called these 216,320 fertile acres home. Some historians estimate that there were never more than a couple thousand Indians who lived between the wide river and great ocean on land that now comprises seven of New Jersey's southern counties. You might remember the few, however, the next time you spread butter on corn on the cob, devour a plate of oysters, decorate a Halloween pumpkin or simply relish a sea breeze.

# A Breeze Blows in White Settlers

One day in 1641, while Lenape families munched on corn and oysters, fifty or so English families from New Haven by way of New Amsterdam sailed up the Delaware River to Salem Creek, where they disembarked and eventually set about building little houses and tending not-very-big gardens. Their main concern, other than swarms of mosquitoes in warm weather, was overbearing Dutch and Swedish officials who laid claim to land on one or both shores of the river.

Joseph S. Sickler in his *History of Salem* explains:

> It [the settlement of the so-called New Havenists] was destined to be a short existence…The least of their trouble was the swearing of allegiance to the nations who claimed the river. It has been shown that they promised the Dutch they would be their citizens if they settled on Dutch territory. In the absence of certain geographic boundaries, the colonists were probable ignorant of the actual bounds of the Dutch domain. If they were

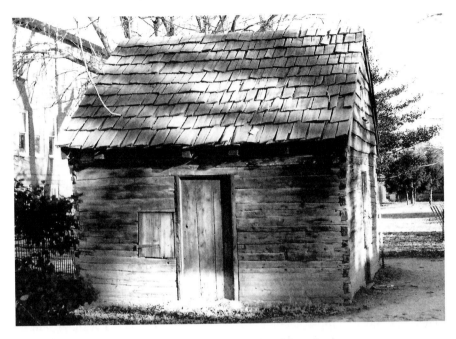

This cabin is typical of the log houses built by early Swedish settlers.

*not, they probably figured they were too far from New Amsterdam to be bothered anyhow. But sometime between 1640 and 1643—the dates are very hard to ascertain—the Swedes at Wilmington came across the river and forced the English at [Salem Creek] to swear allegiance to them. Nothing daunted, the English swore allegiance again, for swearing allegiance was easier than not... The English, fighting the insects and pleurisy, remained at [Salem Creek], but not for long.*

The little settlement began to dissolve by 1643, and hardly any trace of those first English settlers remained on the land when, in November 1675, the ship *Griffin*, bearing another assemblage of English families, disembarked up what would become the Salem River. Their well-intentioned and good-hearted leader was the not-so-good businessman John Fenwick, formerly a major in Oliver Cromwell's army. Fenwick was both a victim of and the cause of monumental financial troubles. On the one hand, he had been deceived by the dishonest wheeler-dealer Edward Byllynge, who had purchased some of the land later conveyed to Fenwick with funds Byllynge actually owed to his creditors. On the other hand, Fenwick owed money to his own creditors back in England. "In his anxiety to formulate plans for his new colony," wrote Sickler, "and worried by the first legal battle over his [agreement] with

Byllynge and other matters, he had neglected to pay his bills [in England]."
Two fellow Quakers bailed him out by agreeing to pay his creditors in return
for a mortgage on the property Fenwick was to acquire overseas in what
would become Salem County. Poor Fenwick was the cause and victim of
financial headaches for the rest of his days.

Fenwick may have been a poor businessman, but he did bring the men
and women aboard the *Griffin* to a land where they would plant a permanent
colony, grow crops guided by the long experience of the Lenape people and
raise generation after generation. Those adventuresome men and women
aboard the *Griffin* are worth noting and remembering. Those people include
Fenwick's three daughters, starting with Elizabeth and her husband, John
Adams, and their three children, Elizabeth, Fenwick and Mary; Priscilla and
her husband, Edward Chimneys, and their two children, John and Mary;
and Anna. Also included in the group were Samuel Nicholson and his wife,
Ann, and their five children, Paroble, Elizabeth, Samuel, Joseph and Abel;
John Smith and his wife, Martha, and their four children, Daniel, Samuel,
David and Sarah; James Nevill; Edward, Robert and Samuel Wade; Richard
Hancock; Samuel Hedge; Isaac Smart; Richard Whitacar; William Malster;
servants Robert Turner, Gervas Bywater, William Wilkinson, Joseph Worth,
Michael Eaton, Eleanor Geere, Zachariah Geere, Sara Hutchens, Ann
Parsons, Mark Reeve, Edward Webb and Elizabeth Waites; and nurse Mary
White. Soon after the arrival of Fenwick's party, Samuel Hedge married
Fenwick's daughter, Anna.

# LONG AGO IN ELSINBORO

Those who relish finding ways to embarrass or make fun of New Jersey and
its residents often claim that nowhere other than in our state will one find
mosquitoes as big and hungry as those that call New Jersey home. Residents
point out that we have no corner on mosquitoes; they can be found anywhere.
Then some wiseguy who thinks he knows the history of New Jersey and,
especially Salem County, brings up Fort Elfsborg. The fort was built on the
east bank of the Delaware River in 1643 at the direction of Johan Printz,
the governor of New Sweden. At the time, Swedish and Dutch settlers were
sharing and disputing land on both sides of the Delaware. In addition to
quarreling with each other, representatives of both countries wanted to
keep out English settlers, and they came down hard on people of a small

English colony called the New Havenists, who existed briefly and miserably on the land that became Elsinboro. The Dutch finally prevailed and took command of Fort Elfsborg, Most historians claim the Swedish soldiers manning Fort Elfsborg evacuated to avoid capture or death at the hands of a larger Dutch force, but the more often cited and believed account says the Swedes departed the fort earlier and were pleased to leave the mosquitoes to the Dutch.

The English, of course, returned to Salem County and the area called Wootsessungsing by the Lenapes, Elfsborg by the Swedes and Elsinboro by the English. An early settler was Richard Darkin, who historians Thomas Cushing and Charles Sheppard refer to as "one of the most active and useful young men in the colony. He was a zealous Friend and took a conspicuous part in the religious meetings of his sect." To be sure, Darkin's name is cut into field stone that is included in the Memory Walk created in 1941 by Salem Quarterly Meeting. However, the only other mention of Darkin, the "zealous Friend," in the four-hundred-page history of Salem Quarterly Meeting from 1675 through 1990 is in connection with his appointment in 1701 to a panel of five men who were instructed to "draw a general testimony against such practices" as Friends marrying non-Friends. Presumably, the result of the panel's deliberation was a rule that required Friends marrying non-Friends to be "read out" of the faith.

One of the prominent residents of Elsinboro in the eighteenth century was Benjamin Holme, a colonel in the colonial militia who played an important role in defending the bridge over the Alloways Creek in Quinton against the British during the American Revolution. In retaliation, the British commander, Colonel Charles Mawhood, singled out Holme and other American officers and promised to "burn and destroy their houses and other property and reduce them, their unfortunate wives and children to beggary and distress."

Mawhood made good on his threat. While Holme was away from his house in Elsinboro, British soldiers ordered his family out of their home, pillaged the property and set fire to the house. According to Cushing and Sheppard, Mawhood took a clock from the house before setting it ablaze and carried the clock to New York. Years later the clock was discovered there by a Holme descendent and brought back to Salem County.

# Long Ago in Oldman's Township

## *Roger Pedrick and Indian Tom*

The map of Salem County shows Oldman's Township sitting in the northeast corner, but when you look closer, the name that keeps popping up inside the township's borders is Pedrick: Pedricktown, Pedricktown Station, Pedricktown-Woodstown Road—well, you get the idea. You wonder if the old man was somebody named Pedrick. Good guess! Roger Pedrick, the same who gave his name to 20.3 square miles of very rich farmland, came from St. Paul's Parish in England. He first settled "near Salem," but then "Indians" burned down his cabin. Apparently the loss of his home did not throw him into a panic because shortly thereafter, in 1675, he purchased 1,000 acres of land bordering Gloucester County and the Delaware River. The purchase price was only five pounds. When Roger died, the land was divided up among six sons and two daughters. One ancestor, William H. Pedrick, owned 130 of those acres in the early 1880s, more than two hundred years after Roger decided to move after the Indians burned his cabin.

Then there was Indian Tom. Tom, by all accounts, was of the Lenape tribe that occupied Salem County before it was a county, before the Swedes, the Dutch and the English. According to some historians, the Lenape people "gave up title" to all the land that became Oldman's Township, Salem County and New Jersey in about 1801. Of course, the Lenape people never had title to the land. They lived on the land, hunted in its forests, fished in its streams and grew beans in its soil, but they never owned it, never had title to it. In any event, before giving up ownership and certainly after that date, most of the Lenape people moved west, first into Pennsylvania and then even farther west—all the Lenape people except Indian Tom, by all accounts. The local belief, unsubstantiated, is that Tom was left behind for some reason. No one knows for sure how old he was at the time of the exodus, but perhaps his large extended family that included many adults and children thought he was with some members somewhere. In any event, Tom never moved west; he lived alone in a cabin at the edge of a swamp on land that was to become Oldman's Township. He died in that cabin in 1828 or 1829. No one is sure of the date, of course.

## *Parting Friends*

Gideon Scull and his wife, Sarah James, were large landowners along the Gloucester County border, and Gideon was the leading merchant in the area. He owned a fleet of packet boats that carried primarily agricultural

products to Philadelphia and brought back to residents of the area—which became known as Sculltown and later Auburn—whatever they needed for day-to-day living. He and his wife were members of the Pilesgrove Monthly Meeting of the Society of Friends. Indeed, Sarah James was a "recommended minister" in the society.

In the 1820s, when the Sculls were in their mid-sixties, the congregation of the Pilesgrove Monthly Meeting, along with some other congregations throughout the area, split in two. One segment of the congregation, which held to the beliefs and practices they had known all their lives, became known as the Orthodox branch. Other and more numerous members of the group declared they were followers of Elias Hicks, and they called themselves Hicksite Friends. Hicks, who was an itinerant Quaker preacher in Long Island, believed, for example, that most human passions, or "propensities," including basic sexual desires, were natural and not the work of the devil.

The Sculls evidently sided with the Orthodox branch, and Gideon before his death in 1825 donated land for a new wooden-frame building to be erected at the corner of Union and Elm Streets in Woodstown to serve as the place of worship for the Orthodox branch, which turned over the brick meetinghouse on Main Street to the Hicksites.

# BENJAMIN FRANKLIN'S "GLASS HOUSE"

To begin with, Great Britain in the early decades of the eighteenth century discouraged any colonial industry that might compete with any industry in the mother country. Parliament's reasoning was clear: British industries profited very well by selling finished manufactured goods to homeowners and small businesses in the American colonies. It was fine if enterprising individuals in the colonies wanted to supply British industries with raw materials, but Parliament insisted on its subjects purchasing finished goods from British industries—period.

Presumably, Caspar Wistar of Philadelphia, who had joined the Society of Friends and married prominent and prosperous Quaker Catherine Janson in 1727, was acquainted with Great Britain's position regarding manufacturing in the colonies. After all, Wistar was already making brass buttons in the city and earning a decent income, but perhaps Parliament and its representatives didn't consider the manufacture of brass buttons to be a major threat to any maker of brass buttons in the British Isles.

Now we have to presume some of what occurred in the Wistar family and also in the American colonies, principally Salem, between 1727 and 1738. Joseph Sickler, in his *History of Salem County New Jersey*, points us in the right direction:

> *With the rise of the young colonies, the demand for better modes of living led to a widespread demand for window glass and table glassware. From the early factories* [none in New Jersey] *there had come a small supply of glassware, but with this and some importation of glass from England,*

*the demand far exceeded the supply. Therefore, the time was ripe for another colonial attempt to supply glass.*

Perhaps, as a Friend and the husband of the well-connected Catherine, he was acquainted with the Quakers of Salem downriver from Philadelphia. Perhaps from some of those acquaintances he learned that not only were homeowners in Salem in need of window glass and glassware for use in their homes but that in some parts of Salem there existed extensive deposits of sand—silica, the stuff glass is made of.

In any event, Wistar must have concluded that there existed a bigger and better market for window glass and glassware than there was for brass buttons. Therefore, in 1738 he and/or his wealthy wife—perhaps they combined their savings—purchased one hundred acres of woodland near Alloway from Clement Hall and then bought another several hundred acres from Amos Penton and Amos Hilton, whose property adjoined Hall's.

The next steps were to clear land for a glass-making plant, purchase furnaces and, of course, cut wood for the furnaces. Oh yes, Wistar the button maker, needed men who knew how to make glass. How he knew about or found four experienced glass blowers is not known, but he paid a sea captain fifty-eight pounds, eight shillings to bring them across the Atlantic. The glass blowers, perhaps from the Netherlands, were named Caspar Halter, Johan Halter, Johann Wentzell and Simon Greismeyer. They were not only good glass blowers, but they also were pretty savvy businessmen. Sickler reports their terms: "They contracted to come to this land and show Wistar the formulas [for] making glass [in return] for money advanced, all expenses [paid], including land, homes, food and servants, and also one-third of the profits from the sale of the manufactured ware." Wistar called the land that his glass works occupied Wistarburgh.

# Forget British Law

By the beginning of the fourth decade of the eighteenth century, many small colonial manufacturers were going around or outright violating British trade laws. According to writer James Rapp,

*The colonies were supposed to supply cheap raw materials to England, where goods could be finished and exported for profit, often enough right back*

> *to the colonies, England's natural captive market. The Navigation, Trade, Plantation and other Acts and policies associated with British mercantilism dictated what a colony could sell, proscribed its trading partners, and set duties and taxes. Even in relatively Loyalist New Jersey, however, citizens and leaders alike worked around the Crown's restrictions.*

Including, of course, Caspar Wistar.

However, what was happening at Wistarburgh in a clearing surrounded by woods had not gone unnoticed by the king's representatives. At the end of July 1740, a year after Wistarburgh commenced operations, Charles Carkesse, secretary to the Commissioners of the Customs in London, wrote a letter to Thomas Hill, secretary to the Lords Commissioners for Trade and Plantations, in which he reported that

> *Mr. William Frazor, Collector of the Customs at Salem, New Jersey, having informed the Commissioners that there has been lately effected a glass work within eight miles of that port by one Caspar Wistar, a Palatine, and is brought to perfection so as to make glass. I am directed to give you and account thereof for the information of the Lords of Trade.*

Apparently, no action was taken to curtail or close down production at Wistarburgh.

## FOLLOWING DAD'S ADVICE

Great Britain required its representatives in the colonies to regularly report on what was transpiring among the colonies' businesses and manufactories. This placed a real burden on those representatives who, in both mind and heart, were pleased to see their fellow countrymen succeed without too much interference from the crown's representatives and without paying too much attention to the British trade laws.

William Franklin, Benjamin's illegitimate son, was royal governor of New Jersey during Wistarburgh's most prosperous years. While he did raise taxes on colonial businesses, he protected the glass works by underreporting its considerable success. This practice, naturally, caused him some anxiety. He turned to his father for advice.

Rapp reported:

*Benjamin reviewed the filings by other colonies and noted, "There are no manufacturers of any consequence" in the colonies, as labor issues appear to render significant business growth "impracticable." Ben concluded, "These accounts are very satisfactory here [Benjamin was in London at the time], and induce the parliament to despise and take no notice...You have only to report a glasshouse for coarse window glass and bottles."*

William heeded his father's advice and, in his next report to the royal government, greatly downplayed both the quality of Wistarburgh glass and the worth of its customers. He stated that Wistarburgh "makes bottles and a very coarse green glass for windows, used only in some houses of the poorest sort of people." His biggest fabrication he saved for last: "The profits by this work have not hitherto been sufficient it seems to induce any persons to set up more of the like kind in this colony." Wistarburgh may have had no competition, but its owners were doing very well indeed.

## One of Wistarburgh's Best Customers

Benjamin had another good reason for convincing his son to downplay the importance and profitability of Wistarburgh. He was one of the company's best customers. The company had a retail business in Philadelphia, and Mr. and Mrs. Wistar retained a home in the city. At one time, Benjamin was their neighbor, according to Rupp. "Franklin had highly specialized glass needs; much of his research involving electricity benefited from custom-made pieces from Wistar. Franklin wrote that he had tubes and globes blown at 'our glass house,' by which he meant Wistarburgh."

Rupp concludes that, without the help of Benjamin and William Franklin, "Caspar Wistar's south Jersey glass factory might have met an earlier demise and not be regarded as the basis of an industry that blossomed during the following century."

Caspar Wistar died in 1752, and his son, Richard, succeeded him. Richard kept the business going throughout most of the American Revolution. He finally put Wistarburgh up for sale in 1780. An advertisement in the *Pennsylvania Gazette* dated October 11 of that year reads as follows;

*The Glass Manufactory in Salem Co., West Jersey is for sale with 1500 acres of land adjoining. It consists [of] two furnaces with all the necessary*

*ovens for cooling the glass, drying wood, etc. Contiguous to the manufactory are two flattening ovens in separate houses, a storehouse, a pot house, a house fitted with table for the cutting of glass, a stamping mill, a rolling mill for the preparing of clay for pot making and, at suitable distances, are ten dwellings for the workmen and likewise a large Mansion House containing six rooms on a floor, with bake house and wash house. Also, a convenient storehouse, where a well assorted retail shop has been kept for thirty years, is as good a stand as any in the county, being situated one and a half miles from a navigable stream, where shallops load for Phila., eight miles from the County seat of Salem and a half mile from a good mill. There are about five hundred acres of cleared land within fence, whereof is mowable meadow which produces hay and pasturage sufficient for 60 head of cattle, with a large barn, granary and wagon house. For terms of sale apply to the subscriber in Phila.*

The subscriber was Richard Wistar.

Caspar and Richard Wistar not only established the first glass works in New Jersey and one of a very few in all of America in the eighteenth century, but they also set standards for succeeding glass-manufacturing plants in later centuries. This legacy will be discussed in a later chapter.

# LONG AGO IN PILESGROVE

It might have been his grove—at ten thousand acres, his was the biggest chunk—but Thomas Pile, an "eminent Friend," rates only a few lines in the chapter on Pilesgrove Township in the huge history tome written by Cushing and Sheppard. Pile bought the land from a Richard Guy, who in turn purchased it from John Fenwick. Cushing and Sheppard call the receipt that Fenwick gave to Guy "quaint and curious," and they quote it verbatim:

*Received the one and thirtieth day of the month, called May, One thousand, six hundred and seventy-five, of and from Richard Guy of the Parish of Stepney, alias Stenbunheath in the county of Middlesex, Cheeseemonger, [Guy made and sold cheese?], the full sum of fifty pounds Sterling, which is the same sum of fifty pounds mentioned and expressed in a certain Deed Poll bearing even date herewith, and made from me, John Fenwick, late of Binfield in the county of Berks within the kingdom of England, Esquire and chief proprietor of the*

*one moyetie or halfe parts of the Tract of Land within the Province of New Casaria, or New Jersey, in America, to the said Richard Guy. By me, Fenwick.*

Pile had three daughters, and one daughter, Elizabeth, married William Hall, a judge in Salem. It is generally believed that Hall, through his wife, acquired a considerable number of those ten thousand acres that Pile purchased for fifty pounds. Cushing and Sheppard believe Pile died in the late 1680s. So much for the man who gave his name to Pilesgrove Township.

## Another Name, More Notoriety

Whereas Thomas Pile lent his name to a lot of territory and then seemed to fade into obscurity, Isaac Sharp not only had his name attached to a piece of Pilesgrove but he and his progeny also gained some fame. Sharp arrived in America and Salem County from Ireland in 1730. He took possession of six hundred acres that had been purchased for him by his father. According to historians, Sharp brought with him on board the boat from Ireland the frame of his house-to-be. Yes, you read that correctly: the frame of his house. How he managed that on the topsy-turvy Atlantic, one can hardly imagine. Eleven years later, the young immigrant was appointed a judge of the Salem Court. He died prior to the Revolution.

When war did come to Salem County and British soldiers on foraging expeditions ranged throughout the county, Anthony Sharp, Isaac's youngest son and also a Quaker, hid in the family barn until the soldiers left the county. It wasn't that he was afraid—he was saving himself for real action. It came when Dr. Ebeneezer Elmer came by and invited him to go north and do battle against the British in upper New York and along the frontier with Canada. Although he remained a Quaker in his heart and soul, Anthony stayed in the army and rose to the rank of colonel.

British soldiers returned to the area—later to be called Sharptown—and drove the Sharp family and presumably other families from their homes before commencing the looting. However, before they left their home, they gathered up silver plates and whatever other valuables they could carry and, along with friends, boarded a boat crossing the Delaware River.

## The Richmans Before They Made Ice Cream

Another family that figured prominently in the history of Pilesgrove Township was that of John Richman, who came to Salem County from

Germany. The family name was attached to a section of Pilesgrove called Richmanville. The family was noted for its sawmills and a fulling mill that was later converted into a foundry. Not content with sawmills and a fulling mill, the Richmans also built and ran a gristmill.

## Long Ago in Quinton

Tobias Quinton was among those early settlers who sailed from England in the wake of Fenwick's ship, *Griffin*. While he gave his name to 13,500 acres of pretty good land, Richard Johnson, who followed Tobias to America and to the shores of Alloways Creek, eventually owned not only a sizable number of those acres but also a hefty chunk of what became Salem County. Cushing and Sheppard refer to Johnson as "a man of ability," whose outstanding ability was buying up acreage. Some of the land owned by Johnson later became the site of the Quinton Glass Works.

Another early settler was John Tyler, who brought with him a letter signed by fourteen people, perhaps best friends and/or business associates, who testified to his upstanding character:

> *We, therefore, whose names are subscribed, do hereby certify that the said William Tyler hath been ready and willing to contribute to the service of truth, as opportunity hath offered and occasion required, and that as to his dealings with the world he has been punctual and of good report as far as any of us know or have heard, and we know nothing of debts or other entanglements on his part.*

Tyler became a farmer and tanner, and according to Cushing and Sheppard, "his descendants became well-known citizens of Quinton and adjoining townships."

While, in the late seventeenth century, Tobias Quinton unofficially bestowed his name on that body of land south and west of Alloways Creek, it did not officially become an independent township until the last quarter of the nineteenth century. According to historian Joseph Sickler, Quinton Township resulted from some good old-fashioned political maneuvering on the part of the state legislature: "The Republicans in the Legislature did succeed in carving a new township out of Upper Alloways Creek, which they named Quinton. It was another gerrymander by which the township was so divided that the new municipality would be Republican." The year was 1873.

Quinton is primarily known for what happened at the bridge over Alloways Creek during the American Revolution and what developed much later on the south bank of that waterway. The incident at the bridge was more than a mere skirmish and less than a major battle and is described elsewhere in this book. Also mentioned elsewhere is an account of the glass works that prospered in Quinton, but it is noted here that approximately 150 people were employed at the Quinton Glass Works in its nineteenth-century heyday, and nearly all of them lived in housing built on site by the company.

## Saving Burden Hill

In their nineteenth-century history of the area, Cushing and Sheppard refer to two distinct land prominences as Borden's and Turnip Hills. One is now known as Burden Hill and figures prominently in land preservation plans proposed by the New Jersey Conservation Foundation. According to the foundation, Burden Hill now comprises 15,000 acres, of which 615 acres are included in the foundation's Burden Hill Forest Preserve in Quinton. The foundation seeks to acquire additional acreage in Quinton Township as part of its effort to preserve a region that is "home to a diversity of plants and wildlife that make up and inhabit the vanishing upland forests…that support migratory songbirds, several species of hawks and the American bald eagle."

## HAROLD SMICK REMEMBERS

B. Harold Smick Jr. of Salem boasts a family link between the dawn and decline of the pioneering and profitable glass industry in Salem County. When Caspar Wistar commenced his search for glass blowers and other men needed to work in his glass works, Wistar in the decades prior to the American Revolution looked to Germany, his home country. The first four men he hired and talked into coming to an America on the verge of revolution were Caspar Halter, John Martin Halter, Johannis Wentzel and Simeon Kreismayer. Soon thereafter, he hired Johan Philip Smick, Harold Smick's ancestor. Smick was thirty years old when he came to work at Wistarburgh in 1748. Philip's heir, William, served in the Salem County militia during the American Revolution and was in action at the bridge in Quinton. He survived the war and lived to age ninety-four.

# Benjamin Franklin's "Glass House"

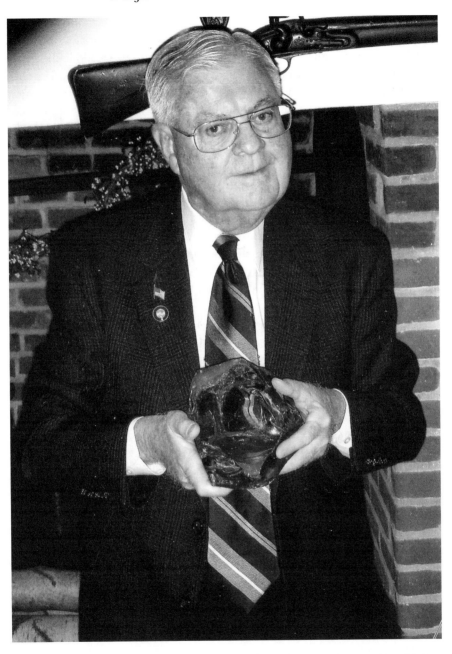

Harold Smick displays one of the pieces of glass that came from the Quinton Glass Works.

Fast forward to Quinton in 1906 and to the south bank of Alloways Creek, a musket ball's throw from Quinton's Bridge that William Smick helped defend in 1778. In that sixth year of the twentieth century, Harold's grandfather, Isaac, became owner of the lumberyard adjacent to Quinton Glass Works, once a major industry in the county and one of the premier glass manufacturing companies in America. Of course, the lumberyard prospered and is today owned and operated by the Smick family. The Quinton Glass Works, on the other hand, closed for good in 1908, but many years later when the lumberyard was rebuilding after a fire in 1963, Harold and others uncovered pieces of glass of various shapes and sizes in the ground where the buildings of the Quinton Glass Works once stood and the company once flourished. Harold proudly displays the glass pieces in the home on Amwellbury Road he shares with wife Claire. Perhaps Harold's closest connection to the Quinton Glass Works was when he once lived above the general store that the glass works had owned and operated for many years.

Today the Smicks live in a glazed-brick house built in 1752 by Samuel Nicholson. The house features a "hearse door." Harold explains: "The door opens to the outside, but there are no steps going down. The reason no steps were built was to allow the undertaker to back his horse and wagon up to the door and carry on the coffin of the deceased." The Smicks have owned the house since 1963. Harold served as chairman of the National Lumber and Building Material Dealers Association in 1995. He has been active in Rotary both locally and at the national level. In 2004, he was presented the Service Above Self Award by Rotary International.

# FORAGING AND FIGHTING

I t was a pleasant day in May. The year was 1777. The United States of America was eleven months old and at war with Great Britain. The New Jersey legislature, whose sessions were called to order in various locations depending on the whereabouts of the British army, was meeting at the Indian King Tavern in Haddonfield. The main order of business was to examine and hopefully adopt Pierre Eugene du Simitiere's artistic rendering of New Jersey's proposed state seal. Prominent in the center of the seal was a shield that displayed three plows. Above the shield was a helmet, denoting sovereignty. On top of the helmet was a horse's head. Two female figures stood on either side of the shield. One was Liberty; she carried a staff. The other was Ceres, the Roman goddess of grain. She held a cornucopia filled to the brim with the fruits of harvest. The legislature unanimously adopted the seal.

In that year, when the war was going badly for the new nation, perhaps nowhere in the state was the plow more in use and more horses and cattle grazed than in Salem County. That is to say, Salem County farms in that decade of the eighteenth century were as productive and bountiful as might be expected given the circumstances. Unfortunately, the circumstances were such that the fertile soil of New Jersey, like that in much of the new nation, was becoming less fertile each year.

People writing about the state of agriculture in the colony-state of New Jersey in the middle of the eighteenth century were mostly alarmed at the condition of the soil and concerned about its ability to provide the crops

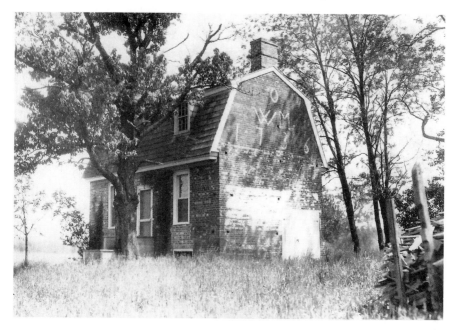

The Oakford house was built in 1736. *Courtesy of* Today's Sunbeam.

necessary to feed farm animals and farm families. The author of *American Husbandry*, writing in 1775, warned, "There is no error of husbandry of worse consequence than not being sufficiently solicitous about manure; it is this error which makes the planters in New Jersey and our other colonies seem to have but one object, which is plowing up fresh land." Colonel Charles Read, writing in his journal at about the same time, pointed out that most of the land planted by Lenape women and later farmed by English, Swedish and Dutch settlers had lost much of its fertility by the time the New Jersey legislature was examining du Simitiere's rendering of the state seal. One of the reasons was that a fair number of the early European settlers in Salem County had had little or no experience scratching a productive farm out of wilderness.

Soil erosion caused by rain storms common to southern New Jersey was a problem. At the time, no one knew how best to control erosion. Hubert G. Schmidt, writing two hundred years later, reported that most eighteenth-century farmers dealt with erosion by simply abandoning the land.

He wrote:

> *Where erosion affected only part of a field, continuing farming operations eventually exposed the subsoil, thus creating discernible 'red spots' in red shale areas. It has been calculated that New Jersey has lost more than half*

*its soil since its first settlement. This calamity was perhaps inevitable, since the frame of mind that went with extensive agriculture was hardly one to cope with erosion losses.*

Finnish-Swedish explorer Peter Kalm, who visited Salem and other areas of New Jersey and the colonies in the 1750s and '60s, frequently compared agricultural practices in America with those long in practice in Europe. Ours never fared very well by comparison.

Here is his evaluation of our soil:

*The soil here consists for the greatest part of sand, which is more or less mixed with clay. Both the sand and the clay are of the color of pale bricks. To judge by appearance, the ground is none of the best, and this conjecture is verified by the inhabitants of the country. When a grain field has been obliged to bear the same kind of product for three years in succession, it does not after that produce anything at all if it be not well manured or allowed to lie fallow for a few years. Manure is very difficult to obtain and, therefore, people rather leave the field uncultivated. The cattle here are neither housed in winter nor tended in the fields, and for this reason they cannot gather a sufficient quantity of dung.*

## BEST AVAILABLE

After reading the observations and criticisms of eighteenth-century travelers and journalists who, one presumes, were knowledgeable about the uses of land and agricultural practices that they evaluated and criticized, one must wonder why, during the American Revolution, the opposing armies regarded southern New Jersey in general and Salem County in particular as a most necessary and desirable larder. The answer is simple: the corn, hay, cattle and other farm products of Salem, Gloucester and Burlington County farms were, at the time, the best available and, in most cases, the most accessible.

In October 1777, the Continental army under General George Washington took a beating from General William Howe's British army in Germantown on the outskirts of Philadelphia. Shortly thereafter, the British took possession of Philadelphia, and in December, what was left of Washington's army made camp in Valley Forge, Pennsylvania.

Officers and men of both armies and the Tory families who hosted General Howe and his entourage in Philadelphia needed to be fed. The farms in and around Philadelphia already had been picked pretty clean by the armies in their comings and goings since the commencement of hostilities. It required perhaps no extended thought then on the part of the leaders for both sides to take note that the southern counties of New Jersey had thus far been spared from any significant military activity.

Of course, it was the officers and men of Washington's army who were in the direst straits, existing primarily in tents and rude huts and nibbling at dwindling rations. Then on January 15, 1778, General Washington received a note from Colonel Joseph Ellis, leader of militia forces in Salem, Gloucester and Burlington Counties in New Jersey, advising that he had about five hundred men under his command and that he had arranged to have many of the cattle in the three counties moved off farms along the Delaware River to locales farther inland so that they would be less accessible to British foraging parties that might be dispatched from Philadelphia. As far as we know, Ellis, in his letter, did not issue a specific invitation to Washington to come and get as many of the cattle as he and his men needed.

Washington, however, did not need a printed, detailed invitation. He turned to Brigadier General Anthony Wayne and together, and probably in conference with other members of Washington's staff, they considered the best way that could be devised to round up cattle in southern New Jersey and ferry them across the river and into camp at Valley Forge. Wayne volunteered to go get the cattle. It was decided that Wayne and a detachment of men under his command would circle British-occupied Philadelphia, arrive at Wilmington, Delaware, and then cross the ice-filled river into Salem County. There they would round up as many cattle as they could and drive them north through Gloucester and Burlington Counties, getting more cattle as they went. Then the detachment would ferry all the cattle across the Delaware into Pennsylvania above Philadelphia and drive them to Valley Forge.

On February 19, Wayne and his men arrived in Salem and proceeded to round up cattle. They spent nearly two days in the county before driving the cattle north along the so-called King's Highway toward Gloucester and Burlington Counties. In a letter he sent to Washington from Haddonfield on February 25, Wayne reported that his men had collected 150 head of cattle but that some landowners had made the roundup difficult when they attempted to hide their cattle in forest or swamp.

The British, who had for the most part been caught off guard by Wayne and his men, were alerted by Hugh Cowperthwaite, a notorious Tory living in Salem

County. It is not certain as to when Cowperthwaite delivered his intelligence to British authorities, but in any event, no British troops or Tory units were ever successful in intercepting Wayne and his men or in preventing the cattle from being ferried across the river as originally planned. Unfortunately for the residents of Salem County, the British, having been unable to intercept Wayne and his party, decided to punish county residents for having been in most cases reluctant suppliers of cattle for the Continental army.

British soldiers and their Tory accomplices conducted their own foraging—plundering—party, but mostly they burned some fields and houses and stole what they could lay their hands on at other homes. Joseph Sickler recounted what happened to one Salem County resident:

> *Poor Margaret Hall, whose farm faced the Delaware River, lamented that 'when Abercrombie's army was at Salem ye 2d Mo. 1778, there was taken by the flat boatmen, 7 blankets as good as new; 5 coverlets, three almost new; 1 bed quilt; sheets and pillow cases, I can't tell how many; 3 hats; 1 new great coat; several pairs of gloves; a new apron; a pair of stuff shoes; 5 or 6 pewter plates; 1 3-qt. burnt china bowl and 1 2-qt enameled ditto and 1 2-pint ditto; a hide of neat leather, and several crocks. A house torn to pieces.*

## CONFRONTATION AT QUINTON'S BRIDGE

Alloways Creek, named for the Lenape Indian chief, meanders across Salem County from west to east and provides a kind of dividing line between the town of Salem and communities in the north and county farmland to the south. The Salem County militia, therefore, was intent on blocking, or at least harassing, British foraging parties attempting to gain access to the plantations south of the creek. The militia then placed defenders at the two major crossings of the creek, at Quinton and Lower Alloways Creek.

On March 18, 1778, not more than a month after Wayne's successful cattle roundup, Colonel Charles Mawhood and Major John G. Simcoe led a British foraging party into Salem County. According to Simcoe's memoir, "Colonel Mawhood had given the strictest charge against plundering; and Major Simcoe [speaking of himself in the third person] in taking the horses, had assured the inhabitants that they should be returned, or paid for, if they did not appear in arms...and none but officers entering the houses."

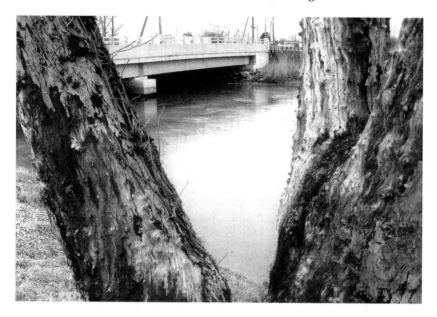

The bridge over Alloways Creek as it looks today. The view is from the bank where American militiamen defended against British regulars.

Of course, the local militia had good reason, based on previous British intrusions into the county, not to believe that present British raiders would be so considerate and respectful. On this date, forces under Mawhood and Simcoe approached the bridge at Quinton. The British officers saw the American militia positioned across the bridge ready to prevent the British soldiers from crossing. They also saw a house not far from where they stood on their side of the bridge, and a plan started cooking in Mawhood's brain. Simcoe describes the moment in his memoir: "Colonel Mawhood asked Major Simcoe, whether he thought, if 'he left a party in the house, the enemy would pass by it or not?' who replied, 'that he thought they would be too cowardly to do it, but at any rate the attempt could do no harm, and if he [Mawhood] pleased, he [Simcoe] would try."

Just as Mawhood and Simcoe were working out their scheme, farmer Andrew Bacon came upon the scene. He decided that the British foraging party could be prevented from crossing the creek and plundering farms to the south if the bridge crossing the creek were destroyed. And who better to carry out the destruction than himself? "He obtained an axe and began chopping, right out in the open, with the British bullets whizzing around him. He succeeded in dumping the draw into the creek without even being scratched, although he received a shot in the leg as he climbed back into the earthworks."

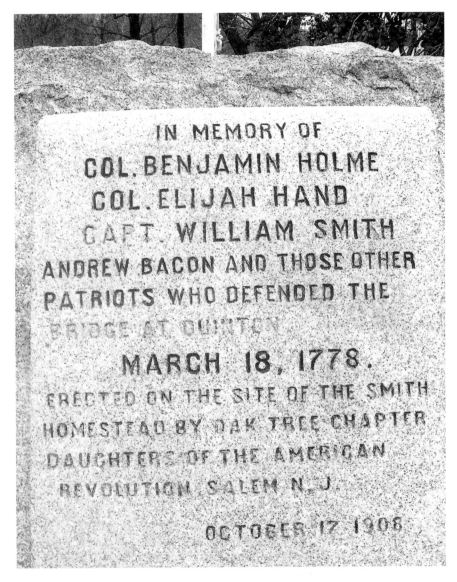

IN MEMORY OF
COL. BENJAMIN HOLME
COL. ELIJAH HAND
CAPT. WILLIAM SMITH
ANDREW BACON AND THOSE OTHER
PATRIOTS WHO DEFENDED THE
BRIDGE AT QUINTON

MARCH 18, 1778.
ERECTED ON THE SITE OF THE SMITH
HOMESTEAD BY OAK TREE CHAPTER
DAUGHTERS OF THE AMERICAN
REVOLUTION SALEM N.J.

OCTOBER 17 1908

This plaque commemorates the battle at the bridge in Quinton when American militiamen prevented British regulars from crossing over Alloways Creek.

Captain William Smith, commanding the militia, had been given explicit orders not to cross the creek, but perhaps emboldened by Bacon's deed, he decided to have planks laid across the creek next to the axed bridge so that his men might attack the British troops on the other side—the troops he could see who were no greater in number than his own. Smith did lead his

men across the planks, and the British soldiers on the other side appeared to be retreating back down the road to Salem town. When Smith's men came opposite the Weatherby house where Simcoe had hidden soldiers according to Mawhood's plan, the militia came under heavy fire and was forced to beat a hasty retreat back across the creek. Mawhood, in his report of the incident at Quinton's Bridge, stated that twenty militiamen were killed and twelve taken prisoner. Colonel Benjamin Holme, the overall commander of militia, reported six of his men were killed by enemy fire and one man drowned in the creek.

Incidentally, Andrew Bacon lived to the age of one hundred.

## MASSACRE AT HANCOCK'S BRIDGE

In the days following the confrontation at Quinton's Bridge, British forces under Mawhood continued to forage on the farms north of Alloways Creek. According to Sickler,

> *Under various detachments of armed men, food supplies and forage were transported to the flatboats lying in Salem Creek. Thus, the rich farm lands around Salem were carefully despoiled of their produce, which was sent to Philadelphia to augment the British food supplies. It still irked the British that they had as yet been unable to cross Alloways Creek.*

Mawhood and Simcoe decided it was time to rid themselves of the irk, and so they set about devising yet another plan, this one centered on the crossing at Lower Alloways Creek. To begin, Simcoe climbed a tree overlooking the bridge and the surrounding buildings, including the home belonging to Judge William Hancock. Indeed, the judge's family had given its name to the bridge. Simcoe drew a map of the surroundings. Unlike the plan at Quinton, Simcoe's new scheme did not involve Hancock's Bridge directly. He did not consider an initial assault over the bridge nor did he figure he could again lure the American forces to cross over the bridge and walk into an ambush. What he did propose was to float his men upstream from the marshes on flatboats at night before dawn and surprise the militia, most of whose members would be asleep in the Hancock House, where they were quartered.

Simcoe describes how the plan unfolded the night of March 20:

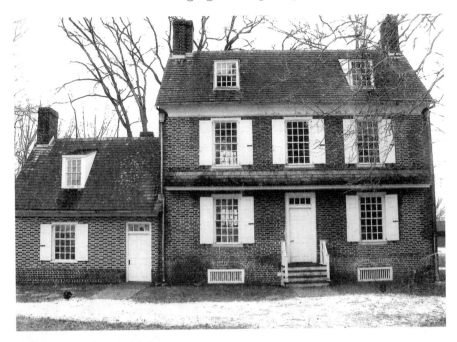

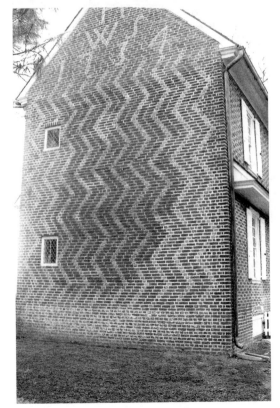

*Above*: The home of Judge William Hancock was the scene of one of the most brutal massacres of American militiamen during the American Revolution. Judge Hancock also was bayoneted as he slept in bed.

*Left*: The west wall of the Hancock house is an example of patterned brick found in several dozen homes in Salem County, the most in any one location in America. These homes, mostly built prior to the American Revolution, feature glazed header bricks arranged to show the initials of the builders-owners, the date of construction and whatever pattern the builders-owners choose. The date for the Hancock house is 1734.

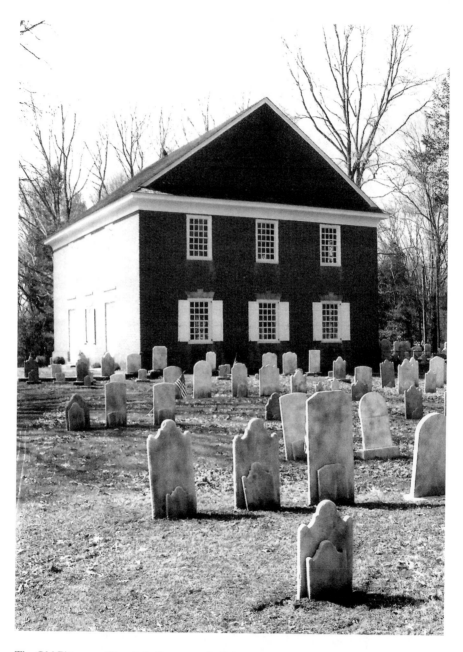

The Old Pittsgrove Church in Daretown, built in 1767, replaced a 1741 log church that included in its congregation a few of the remaining Lenape Indians.

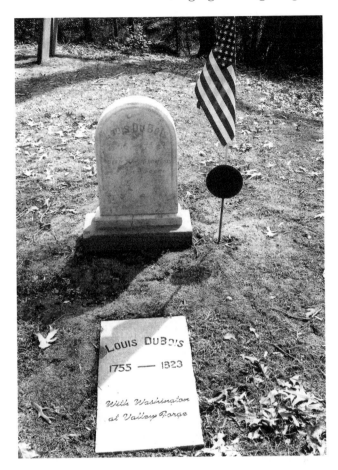

LOUIS DUBOIS
1755 — 1823

With Washington
at Valley Forge

The headstone marks the grave of Louis DuBois, a veteran of the American Revolution who was with Washington at Valley Forge.

*On approaching the place, two sentries were discovered: two men of the light infantry followed them, and, as they turned about, bayoneted them; the companies rushed in and each, with proper guides, forced the quarters allotted to it. No resistance being made, the light infantry, who were in reserve, reached Hancock's house by the road and forced the front door, at the same time that Captain Dunlop, by a more difficult way, entered the back door; as it was very dark, these companies had nearly attacked each other. The surprise was completed and would have been so had the whole of the enemy's force been present, but, fortunately for them, they had quitted it the evening before, leaving a detachment of twenty or thirty men, all of whom were killed."*

One of those people killed was the elderly Judge Hancock, who was asleep in his bed. Sickler, in his vivid report of the massacre, states that some of Simcoe's men were members of a Tory brigade recruited from

Salem County and that some of the sleeping militiamen had been before the war their friends and neighbors. "Men were killed with the names of old acquaintances in their mouths, some begging for their lives and naming the men who were their murderers."

## Long Ago in Upper Pittsgrove

In 1714, two important land speculators, Daniel Coxe of Burlington County and Judge William Hall of Salem County, who together owned much of what became Upper Pittsgrove Township, invited a "colony" of families who had recently settled temporarily in Ulster County, New York, to travel south and check out the land owned by Messrs Coxe and Hall. Cushing and Sheppard, authors of the *History of the Counties of Gloucester, Salem and Cumberland New Jersey*, do not explain how Coxe and Hall located the colony or why families living in the lush Hudson Valley would want to leave that land and travel the long distance to Salem County. In any event, according to the historians, Coxe and Hall invited the colony to "come on their lands in Salem County, representing the excellent quality of the soil and its adaptability and the local conveniences [unspecified] and surroundings, offering favorable terms to all who would become landowners and settlers on the tract." As it turned out, the colony consisted of families who had lived for some time in Ulster County and other families who had recently arrived from overseas.

Cushing and Sheppard record what happened next:

> *The colony sent some of their number to view the land and take careful account of the advantages and disadvantages of the locality, as well as to confer with the proprietors concerning prices and credits, with instructions to accept the offer of Messers [sic] Coxe and Hall on behalf of the colony if the committee should be satisfied that the proposed measure was likely to prove of benefit to the expectant settlers. Large tracts were purchased by the committee in pursuance of further instructions of the colonists, and several families moved on their new possession in 1714 or in the spring of 1715. Prominent among these settlers were the Van Meter and the Dubois families, who took up three thousand acres and the Newkirks, Garrsons, Barnetts, Craigs, Dunlaps, Aldermans and Mayhews, all of whom were liberal purchasers. The Coombs and other families soon followed. It is*

*a fact somewhat remarkable that a majority of the residents of Upper Pittsgrove at this time [circa 1883] are descendants of those colonists who first made openings in the forests of the township nearly 170 years ago, the different families having intermarried during successive generations until the outgrowth has been a relationship so complicated as to defy the most expert genealogist.*

The van Meter family, in particular, became major landowners in Upper Pittsgrove. They continued to purchase property until they eventually owned six thousand acres.

## Sorcerer or Gifted Preacher?

In 1772, a remarkable man by the name of Benjamin Abbott appeared on the scene and later made a scene. By his own admission, he was intemperate and quarrelsome when one night in 1772 he went to the Upper Pittsgrove home of John Murphy, a friend, and heard Abraham Whitworth, a traveling Methodist minister. As a result of that encounter, Abbott said later that the "Devil and the Lord wrested for my soul" until, finally, "I was saved from sin and filled with unspeakable raptures of joy." For the next twenty-four years, Abbott devoted his life to preaching, and he is generally credited with being the person most responsible for introducing Methodism into Salem County, whose residents in the eighteenth century consisted primarily of Quakers and Presbyterians.

Cushing and Sheppard had this to say about Abbott:

*As an exhorter and a weaver of spells over his listeners, he had no equal in his time or possible at all in the history of the evangelical Methodist church. After the lapse of a century even his appreciative supporters in the church are unable to account very clearly for his great power of swaying audiences. The amazing feature of his leadership was that he could cause men and women in his audience to drop on the floor as if slain by a bullet and remain there for hours in a trance. The Rev. Abel Stevens, in his monumental four-volume history of the Methodist Church, pays more attention to the record of Abbott than that of any other pioneer of that faith save only the giants of the cause, Wesley, Whitefield and Asbury.*

# Long Ago in Salem City

In the Salem County seat on October 13, 1774, nearly two years before the Declaration of Independence was adopted upriver in Philadelphia, Grant Gibbon, age forty-four, "a merchant and a man of culture and prepossessing manners," stood before a "meeting of the inhabitants of Salem town and county" and advised them that citizens like themselves living far north in Boston were under siege and under duress from British soldiers occupying the city. Gibbon explained to those assembled that their fellow Americans needed help—financial help—and they needed it now.

Those people assembled responded generously. According to Cushing and Sheppard, "[Gibbon] succeeded in collecting about seven hundred dollars, a large sum at that time, which was sent for the relief of the distressed of [Boston]." Sadly, Gibbon died one week before the Declaration of Independence was signed.

These are two of the eighteenth-century houses that line Market Street in Salem city. The house at left belonged to a descendant of Caspar Wistar, the eighteenth-century glassmaker. The other house was owned by Jacob Hufty.

*Above*: These are some of the older houses on Market Street in Salem city.

*Left*: The Ephram Haines house has stood on Market Street in Salem city since 1760.

Gibbon was one of a number of city residents and Patriots who not only roused their neighbors along Broadway and Market Streets to the cause but also influenced the people of the county. Another one of those men was the highly educated Dr. Samuel Dick of Scotch-Irish descent, who, with his mother, purchased a house at the corner of East Broadway and Walnut Street in 1770. He lived there later with his wife. In 1776, he was elected a member of New Jersey's Provisional Congress and helped draft the state's first constitution. Dr. Dick also was commissioned a colonel of militia and served throughout the duration of the Revolution. After the war, he was elected to the Congress of the United States and served two years.

## Good Citizens Galore

While the city has produced citizens who figured prominently in state and national affairs, it also has been home to men and women who contributed much to their community and fellow citizens but did not attain high office or notoriety beyond the city or county. Cushing and Sheppard describe a number of these people.

For example, Thomas Killingsworth

> *owned about fifty acres, cornering on East Broadway and Yorke Street. This man was, in some senses, so remarkable as to require more than a passing mention. According to such meager accounts of him as have been handed down to the present generation* [late nineteenth century], *he appears to have been a scholar of more than ordinary attainments for that time, and a man in whose good judgment and integrity the first immigrants to this section had the most implicit confidence. He appears to have been well versed alike in theology and English law. A Baptist preacher of much power and influence, he was instrumental in organizing the first Baptist Society in Salem, in which he was aided by Obadiah Holmes, and it is a remarkable fact that these two were also the judges of the first courts organized in Salem, in 1708, soon after East and West Jersey were united under one government.*

William Tyler was about eighteen when he was apprenticed to Benjamin Acton of the city for four years to learn the trade of tanner and currier. When the four years were up, he sold some property out of the city that he had inherited and purchased a "new brick house" in town. "Here he carried on the tanning business," according to Cushing and Sheppard. "His descendants

This tiny building in Salem city is believed to be the oldest law office in America. *Courtesy of Today's Sunbeam.*

have been well known in Salem to the present day [late nineteenth century], and some of them have been identified almost constantly with the tanning and leather interests there and elsewhere."

## Youth Takes Over

The *Salem Messenger* of November 5, 1821, announced that a meeting was to be held that night in Hackett's Hotel to determine if enough young men of the city were willing and able to form a new fire company to be called the Union Fire Company. The newspaper explained that the present, "older, semi-organized company with a large membership of old men had failed to please the populace, who firmly believed that younger men should be in charge of this very necessary protection of the citizens." The newspaper did not elaborate on the nature of the populace's displeasure.

In any event, the meeting was held, and the Union Fire Company was formed. According to historian Joseph Sickler, "The old company [of 'old men'], whose members resigned on account of public pressure, included such well-known sons of Salem as Robert Gibbon Johnson, who was fifty years of age when this step was taken." Johnson has been credited (probably erroneously) with introducing the people of Salem to the tomato or vice versa.

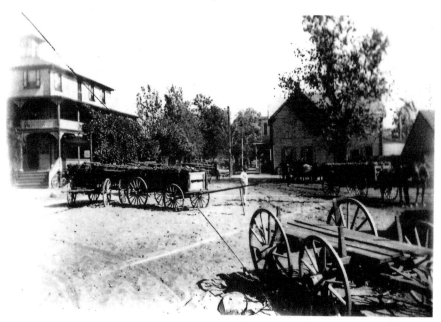

A time when life was simpler. *Courtesy of* Today's Sunbeam.

The old members resigned as they were supposed to, but perhaps they didn't go as quietly and submissively as expected. According to Sickler, "[A committee was] appointed to collect the buckets from the old members...The buckets committee reported little progress as they said 'irresponsible' persons had taken the buckets." The paper did not elaborate on the displeasure.

CHAPTER 4

# RECLAIMING THE LAND

The contending armies of the Revolution may have foraged extensively and to good purpose, but if anything, the condition of the soil—its fertility—had deteriorated further. By the dawn of the nineteenth century, Salem County land had been used and misused by settlers from Europe for more than a century.

Historian John Cunningham wrote:

> *America must have seemed to the first colonists like a heavily laden banquet table seems to a man dying from starvation. Most of the early settlers had come from countries where even a tiny patch of ground merited respect and careful attention. Here, in all this natural largesse, the colonist forgot sound husbandry and laid to with frenzied carelessness. As the starved man eats his way to obesity, they plowed their way to ruin.*

The practice of the typical farmer of the time—wear out one patch of land and then move on—finally resulted in landowners moving not to the next piece of Salem County but migrating west—far west. Sickler, in his history of Salem County, described what happened:

> *Farms were left deserted, the mortgagees taking them as they were; the fields were left unsown and unploughed as the heart-sick natives, whose sires had lived on this soil for a hundred years, left their poverty stricken ancestral estates in Lower Alloways Creek, Elsinboro and Pittsgrove to seek a new*

*living elsewhere. The tide was first directed towards western New York and western Pennsylvania. As the Indians fled westward, the hardier pioneers penetrated to the forests of Ohio in the very start of the winning of the west. Thus it was that Salem, Ohio was founded in 1803 by Zadock Street of Salem, New Jersey. It was the same idea, the hope for gain in the west and the failure in the east which motivated William Wayman and Samuel Jones of Woodstown to advertise in 1800, their grist and saw mill near Woodstown for sale and their hope that the purchaser would exchange lands of western Pennsylvania and New York in part pay.*

If you peruse the map of the United States, you will locate Salems in a number of states leading west to Salem, Oregon.

## "Is This Mud Any Good?"

According to New Jersey history or at least tales told by one generation to the next generation, an unnamed Irishman working on a farm in Monmouth County one day dug into a patch of bluish-greenish mud, wondered what it was and couldn't be sure, but he decided it wouldn't hurt to spread some shovelfuls over the crop he was tending. To his and the landowner's surprise and delight, the mud plainly nourished the crop he had spread it upon and put to shame what crop had been denied the mud. Someone called the mud marl. The year of its discovery was 1768. Unfortunately, it wasn't until the early decades of the nineteenth century, after many families had taken their future west, that many remaining landowners in Salem and other counties appreciated the value of marl and began spreading it on their own farms.

It took some time—a lot of time, actually—before New Jersey landowners, farmers and later scientists discovered that a belt of greensand marl extended from near Sandy Hook in the northeast through four counties and into Salem in the southwest, a distance of about one hundred miles. The belt was ten to twenty miles wide.

Grace Beckett, in her thesis "An Historical Study of Agriculture," writes about the impact marl made:

*When marl was first used, it was dug with a fork and loaded on wagons that carted it directly to the farms. By the middle of the century it had become so popular that distributing companies were formed. Sometimes*

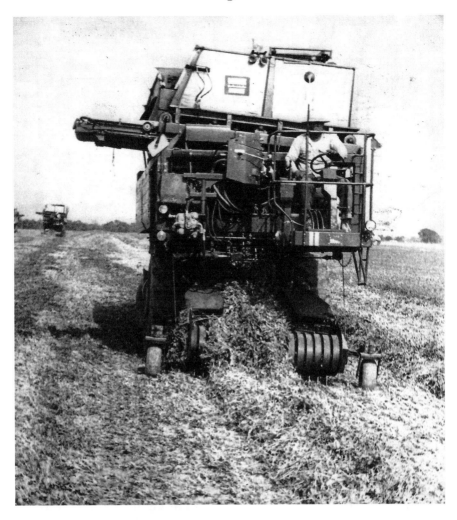

An early combine was used to harvest soybeans. *Courtesy of* Today's Sunbeam.

*these companies built sidings or railroads down into the pits. About 100 to 400 bushels of marl were spread over the surface of one acre of land. The results exceeded all expectations. On fields where the grass was thin and where Indian grass had been prominent, heavy crops of clover, timothy, corn, potatoes and wheat were harvested. In Salem County, it was reported that the corn yield, formerly 15 to 20 bushels to the acre, was increased to 40 to 60 bushels. Potatoes became a highly profitable crop, yielding 150 to 300 bushels to the acre in the year 1840. It was estimated that, by the year 1880, over 500,000 tons of marl had been applied to the light, sandy soil of Pittsgrove and Pilesgrove Townships in Salem County. Marl continued*

This antique scraper once used by local farmers was put out by the road for sale at $200.

*to be used in large quantities until the end of the century when it was almost wholly replaced by commercial fertilizers.*

Historian Joseph Sickler credits the widespread use of marl by Salem County farmers with stemming the westward flow of families. "The importance of this discovery saved Salem County from rapid depopulation and, more than that, laid the groundwork for its future prosperity. Farmers took heart now, mixed the marl with the worn-out soil, and reaped for the first time in years a substantial recompense for their crops. Trade increased with the improvement of the farm situation."

## Long Ago in Pittsgrove

Until the late 1880s, according to historians Thomas Cushing and Charles Sheppard, the township's twenty-nine thousand acres were pretty much "unsettled and unimproved. The settlement of the vast extent of the township south and east of its centre is of such recent date as to preclude any

extended treatment of it in connection with its early occupation." Evidently, the historians weren't too keen about some of the pioneers living at the time of their writing in the "desolate" south end of the township. They described them as settlers "not noted for their enterprise." On the other hand, the inhabitants up around Elmer were "a thrifty and highly respectable class of people noted for their enterprise." Among the latter class of residents were John and Jane Johnson, who emigrated from Ireland in 1756 and, "having considerable means at [their] disposal," bought a large tract of land in the township. Supposedly, Johnson was a Presbyterian minister, but no record exists to say that he preached here.

Apparently John and Jane settled on their land and led an unpretentious life, but their offspring made their marks on township and county. In fact, according to the historians, son Isaac "was determined to own more acres of land than his father possessed at the time of his [the father's] death." He made good on his boast. He acquired six hundred acres of "excellent land and large tracts elsewhere [not specified]." He also acquired or built two flour mills and purchased "much other valuable property." He became Salem County sheriff and was "prominently identified with numerous public and private interest of importance." James, the older son of the Johnsons, served in the Continental army during the Revolution. After the war, he became one of the most successful farmers in the county. The historians conclude that the "descendants of John and Jane Johnson have intermarried with many of the leading families of the county and are to be found widely disseminated throughout the state and beyond its limits."

## Alliance Colony Founded

Cushing and Sheppard devote a single sentence to what turned out to be one of the major events in Pittsgrove history: the founding of Alliance Colony. However, you can't fault the historians; the Russian Jews who formed Alliance Colony didn't start settling in the southeast corner of Pittsgrove until 1882, the year before the historians' tome was published.

The *Jewish Encyclopedia* provides a more detailed account of the settlement:

> *The settlement…was colonized* [on May 10, 1882] *by a contingent of expatriated Russian Jews. There were about twenty-five families in this contingent, and the number was soon increased to forty-three and afterward to sixty-seven. Most of the settlers had been small traders or storekeepers at home. During the summer and early fall of 1883, the colonists supported themselves*

*Above*: This building in Pittsgrove served as a synagogue for the Russian Jews who came to Salem County in the nineteenth century and became the first Jewish agricultural colony in America.

*Below*: These are some of the original chicken coops that were built by the early Jewish settlers in Alliance Colony.

*by working out for the Christian farmers. In the fall, the manufacture of cigars and shirts was undertaken in a part of one of the large buildings formerly occupied by the colonists, and these industries afforded employment for the settlers during the winter of 1883-84. According to contemporary record* (Philadelphia Mercury, *Oct. 20& 27, 1889), as soon as possible the settlers applied for naturalization papers and took active interest in local politics, in which their views were as varied as on religious topcs.*

## Tragic Day

One day in January 1853, Elam Foster was talking with his wife about the upcoming execution of a convicted murderer when their son asked how the murderer would be executed. His father explained that the man would be hung by a rope. To demonstrate, the father took out a handkerchief and wrapped it around his son's neck to simulate a hangman's noose. Later, the boy found another handkerchief and decided to follow his father's example. He wrapped the handkerchief around the neck of his infant sister, who was lying in the cradle, and she suffocated.

# SALEM'S NOT-SO-LITTLE REVOLUTION

Historians date the beginning of America's second Industrial Revolution at about the time the Civil War was ending or a half dozen years thereafter. In Salem County, an industrial revolution of sorts was booming at about the same time the cannons' booms were bouncing off the hills surrounding the bloody fields circling Gettysburg. The cause of Salem County's not-so-little industrial revolution was the realization by small circles of men of vision and resources that the silica-rich sand that Wistar father and son had turned into glass eighty years earlier remained underfoot and ready still to be thrust into the furnace.

The realization commenced in1862 when Henry Hall, Joseph Pancoast and John Craven formed a partnership and built a single furnace on Third Street in Salem city. They turned out bottles for mineral water and beer. Business blossomed, and a second furnace was built on Fourth Street. By the end of the Civil War, the partners were turning out fruit jars for a half dozen companies and hundreds of bottles of various shapes and sizes that eventually would be filled with Atwoods bitters, Carter's ink, Paine's Celery Compound or Lydia Pinkham's Vegetable Compound. While some of the bottles were of standard sizes and shapes and bore the name of the glass works, other bottles were molded to customers' specifications and were emblazoned with the customers' and product names.

The year after Henry Hall and more fired their first furnace, two other glass works were started in Salem County: one later bore the name of the Englishman John Gayner and also was located in Salem city, the second was

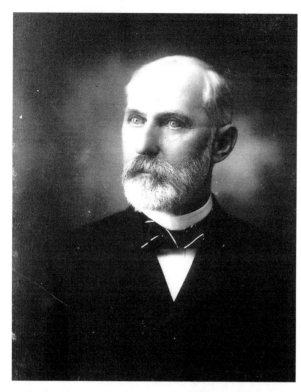

*Left*: Thomas J. Craven was one of the pioneers in glassmaking in Salem County. *Courtesy of* Today's Sunbeam.

*Below*: The old Bradway house once was the office for the Gayner Glass Works. *Courtesy of* Today's Sunbeam.

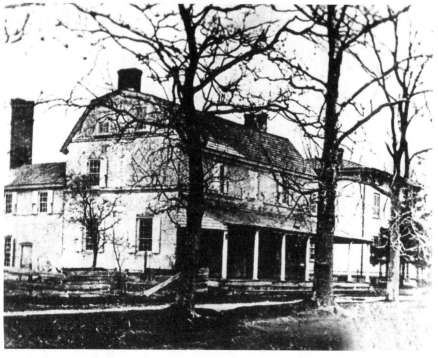

called the Quinton Glass Works. Gayner, who had started a glass factory in Waterford, New Jersey, after immigrating, leased a defunct glass works and changed its name to his, and a team of four men each put up $8,000 to establish the Quinton Glass Works.

## PROSPERING IN THE "CRADLE"

Because of what was happening in Salem and surrounding counties, southern New Jersey became known in some circles as the Cradle of American Glass. In the southwest corner of the cradle, by 1876 sales had so increased for the glass works founded by Hall, Pancoast and Craven that a third furnace had to be built, this one on Griffith Street. Two years later, the partnership underwent change. Hall withdrew, and Pancoast died. Thomas Craven joined his brother, John, and in 1881, they changed the name of the company to Craven Brothers Glass Company. They also built a fourth furnace and increased employment to 350 workers. Meanwhile, Gayner's one-furnace factory at Broadway and Front Street began producing a variety of bottles and jars, two bearing the owner's name: the Gayner Mason Jar and the Gayner Glass Top. Unlike the other two factories, which specialized in the manufacture of glass bottles and jars, the Quinton Glass Works produced mainly window, coach and picture glass. Near the end of the century, in 1895, the Craven Brothers partnership was dissolved and replaced by a stock company, but the Craven and Pancoast families were still at the helm. Also in that year, the company changed its name to Salem Glass Works, and its products also included the mason jar and a Poland Springs water bottle.

## A MOST IMPORTANT INDUSTRY

In the latter quarter of the nineteenth century, the Quinton Glass Works "ranked high among the 26 glass plants then in New Jersey and was well and favorably known nationally for its standards of quality, fair dealing and outstanding service." An 1876 atlas reported that the glass works, which included housing for employees, covered nearly seven acres bordering Alloways Creek and the main road to Salem city: "The Works have an annual capacity for 3 million feet of glass." The works imported a Belgian oven that

"turns out a superior quality of glass…certainly superior to any manufactured elsewhere in the United States. The products of the Quinton Glass Works find a ready market in nearly every state of the Union, the California trade being particularly extensive." The atlas claimed that the Quinton Glass Works "furnished as much, if not more, glass" to the Centennial Exposition taking place in Philadelphia in 1876 than any other manufacturer. Much of the glass manufactured in Quinton was shipped to Philadelphia on barges that were floated west on Alloways Creek to the Delaware River.

Another glass works was founded in the county in 1883. The December 27 issue of the *Camden Daily Courier* reported that the "Elmer Glass Manufacturing Company will be ready to go into operation by the middle of January. The Works will give employment to about 60 men and boys. The factory will contain a four-stone oven and a double set of flattening stones." By 1889, the glass works employed 75 men and was producing "first class window glass." The company was actually divided into an upper and lower works. The upper works was located along the railroad just north of the Elmer-Malaga Road. In addition to window glass, the upper and lower works manufactured bottles, insulators, battery jars and door knobs.

## ONE OF A KIND

The Gayner Glass Company was primarily noted for making carboys, extra large containers often used by the chemical industry. They were still making them by the middle of the twentieth century. Earlier in the century, however, the company ventured unexpectedly, not very wisely and rather briefly into the manufacture of glass coffins. Yes, you read correctly: glass coffins.

Under the headline "Only Place in United States Where They Can Be Made," the *Salem Sunbeam* of July 2, 1909, reported,

> *Complete and perfect glass coffins were successfully made Wednesday at the Gayner Glass Works after the inventor, Dr. Becker of Texas, had tried in all parts of the country to have them made, in every instance without success. The coffins are, of course, transparent and are made in one piece, with the opening at one end.*

The newspaper reported that Dr. Becker thought the glass coffin would be particularly suitable when the deceased had succumbed to a contagious

disease. The corpse could be seen without endangering the health of those people attending the funeral. Dr. Becker and the Gayner Glass Company assured that "the chemical used in making the coffin [not identified] preserves the body and the features of the deceased for an indefinite period and thus [avoiding] the necessity of embalming."

The article quoted Dr. Becker as saying that he scoured the country for a glass works willing and able to make the glass coffin he had conceived. "He is glad to know that the best glass factory in the country is located in Salem."

## AND NOW ANCHOR GLASS CONTAINER

More than 230 years after Wistarburgh banked its fires for good and 135 years after the Salem Glass Works built a third furnace on Griffith Street, the glass industry in Salem County is alive and well in the hands—or furnaces—of Anchor Glass Container Corporation. The corporation traces its history to 1862, when Messrs Hall, Pancoast and Craven got together and decided

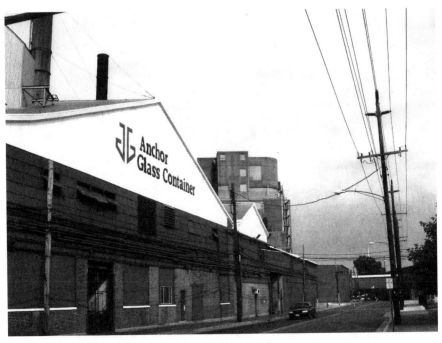

The Anchor Glass Container Corporation plant on Griffith Street in Salem city operates twenty-four hours a day, seven days a week and employs about four hundred people, most of whom are Salem County residents.

to make glass in Salem County. Based on that founding date, Anchor Glass Container Corporation is able to brag that it is the oldest operating glass container manufacturing facility in the United States.

Today, Anchor Glass Container Corporation operates twenty-four hours a day every day, with the exception of two days at Christmas. Its prime customer is the Dr. Pepper Snapple Group, which has its headquarters in Texas and a bottling plant in Cartaret, New Jersey. Today, the plant's 350 employees turn out 173,000 Snapple bottles in eight hours; in 1907, a crew of five men made approximately 2,000 bottles in the same number of hours. The company produces in excess of seven hundred tons of glass every work day.

The company is the primary customer for the West Jersey Short Line Railroad, and the company depends on the railroad to supply it with the raw materials necessary for glass making. Bottles produced by Anchor Glass Container Corporation are shipped by truck.

## Making a Glass Bottle Today

So, one might ask, how does a major manufacturer of glass bottles such as Anchor Glass Container Corporation produce seven hundred tons of glass bottles every day of the year? Here is what modern automation has made possible:

*A completely automatic bottle making machine works like a man. A mechanical feed which allows just the right amount of molten glass to enter the blank mold might be likened to gathering glass on the end of a blow pipe in the old hand method. When pressed into rough shape in the blank mold, it is automatically conveyed into the finishing mold, where compressed air, corresponding to the old fashioned lung power, blows it into finished form. Again, mechanical hands lift the bottle, now fully formed, onto a conveyor, where it travels to, and through the annealing process in what is known as a lehr, and becomes a finished product. Simple as this operation is to describe, it depends upon absolute timing to make it work. There are up to thirty molds on one of our machines. Each blank mold has to receive its proper allotment of molten glass, press it and transfer it to the companion mold to be blown and discharged onto a conveyor. When it's realized that these machines make as many as 400 bottles per minute, it is easy to see that precise timing is the essence of the operation. It should also be realized that with a machine this intricate, once it started, it should be kept in constant operation for a*

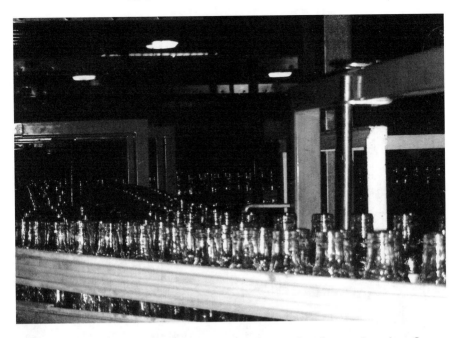

The assembly lines at the Anchor Glass Container Corporation plant produce about five hundred tons of glass bottles each day. That translates into 2,400,000 individual bottles, most of which are destined to be filled with Snapple beverage.

*considerable period of time. Hence, the necessity for a continuous supply of molten glass and the continuous furnace.*

What does a normal batch of glass consist of?
- Silica sand dug in southern New Jersey;
- soda ash mined in Wyoming mines;
- aragonite dredged off the coast of the Bahamas;
- nephylene syenite mined in Ontario, Canada;
- salt cake created as an industrial byproduct;
- and used, broken pieces of glass.

## Suzanne Hancock Culver Remembers

Standing in the back parlor of the 186-year-old brick house set back from Pointers-Auburn Road in Mannington Township, Suzanne Hancock Culver looks down, and at her feet on the floor are faded rings each perhaps five

Suzanne Hancock Culver stands on the spot in the house where her ancestor started a very successful canning business.

Flora and Joseph Hancock. Flora started a cannery in her house before opening an even larger facility in Salem city.

or six inches in diameter. "Those are the marks made by cans of tomatoes placed there when my great-grandmother, Flora Hancock, began her canning business here in the house, which she moved into with her husband, Joseph Griscom Hancock, in 1888."

Suzanne never knew her great-grandmother, but she has collected stories about Flora, and of course, she has her own memories about growing up in that house built by the grandson of Caspar Wistar, the glass maker, and her own connection to tomatoes.

Back in the house's main parlor, where history permeates the air like whiffs of smoke from an oak fire, Suzanne displays newspaper clippings that tell of Flora Hancock's in-house cannery and her later Hancock canneries in Salem city. In one article, Joseph Hancock, Flora's grandson, reported that his grandmother started canning tomatoes shortly after moving into the house. At first, she sold canned tomatoes to neighbors. Then demand increased, and she insisted on enlarging her capacity by installing six kitchen ranges in the farm's wagon shed.

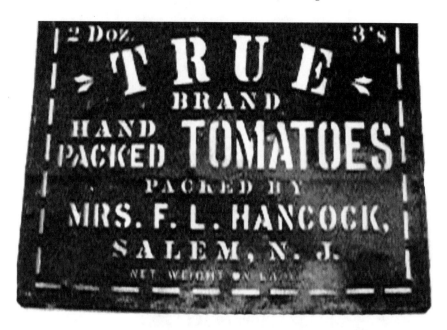

This sign promoted Flora Hancock's preserved tomatoes.

William B. Vanneman in the *Salem Standard and Jerseyman* reported:

*She made a specialty of canning tomatoes for frying. The tomatoes would be cut in half and the core removed, which left large pieces that the housewife could cut into [smaller] pieces for the frying pan. She had a good market in and around Salem; later on when she increased the production, she disposed of some of her stock through a representative in Philadelphia. A good number of [her] workers came from Marshalltown or Frogtown, and others walked to the farm from wherever they lived—some at quite a distance.*

In the early 1900s, at nearly the same time that the Heinz Company was opening its cannery in Salem, Flora moved her business to a building on Hancock Street. Vanneman reported that Flora moved her business again, this time "across from the Salem Sash factory, and operated there for a few years. Her tomatoes were quality items, and it is to her credit that she was able to continue the business as long as she did."

# Salem's Not-So-Little Revolution

## *Getting an Early Start*

What tasks does the great-granddaughter of the legendary Flora Hancock perform on her father's farm? "First of all, the family policy was that everyone worked as much as they were able, depending on age, and I started when I was five." Suzanne's job was to gather up asparagus spears that had already been cut by another worker's hand and were lying on the ground and then place them in boxes on the horse-drawn wagon. It was also family policy that every farm worker, no matter how old or young, was paid for their labor. In the case of the Hancock children, said Suzanne, "We were expected to save whatever we earned and later put it toward tuition for the last year of college. Mom and Dad paid for three years, but we were responsible for the fourth year. So, if you wanted to receive your degree from college, you had better saved enough."

Suzanne saved enough over the next fifteen years to pay for her last year at Cornell University, where she was awarded a bachelor's degree in agricultural economics. Later, at her own expense, she earned a master's degree at Drexel University.

As Suzanne grew older, her farm tasks changed.

> *I started working on the packing line. At first it was bell peppers and, later, we packed tomatoes. When I was in high school, my dad, who was always trying to minimize the labor involved, moved into plum tomatoes, and he got away from so-called stoop labor. In the spring, I would ride the transplanter, which planted the bare root plum tomato plants. When the tomatoes were ready for harvest, we would spray the vines with a chemical called etherol. The chemical would kill the vines but not the tomatoes, and then the exposed tomatoes would ripen at about the same time. When the tomatoes had ripened—sometime in August—we came along with the mechanical harvester. The harvester was pulled by a tractor and straddled a couple of rows. Blades cut what was left of the vine at ground level, and the tomatoes would drop on to a conveyor belt. The conveyer belt would then deposit the tomatoes in a trailer that accompanied the harvester. I was on the harvester, and my job was to throw out any rocks or clumps of dirt that may have been picked up by the blades when they cut off the vines at ground level. Occasionally, we would also find a black snake, which no one was anxious to touch. My joke is that somewhere in the world is a bottle of catsup with essence of black snake. They were hot, long days, and you ate a lot of dust.*

## James Pritchett Remembers

James Pritchett went to work as a paddle loader at Anchor Hocking on Griffith Street in Salem city in 1977. Today the company is known as Anchor Glass Container Corporation, the oldest manufacturer of glass containers in the United States and the latest glass manufacturer in a very long line of glass makers in Salem County. Pritchett is the finished ware manager. That means he is responsible for the production of glass bottles from the time they leave the forming department until the time they arrive at customers' docks, which means that packaging and shipping also come under his authority. Anchor Glass Container is primarily responsible for manufacturing beverage bottles. "We are the 100 percent supplier of bottles for the Cadbury Company in north Jersey, which makes Snapple, Mystic, Nantucket and Yahoo."

The main ingredient in the bottles made by Anchor is sand, according to Pritchett, and the sand comes from Port Norris. The major change in bottle production over the years has been the introduction of new technology, said Pritchett.

James Pritchett, who started working at Anchor Glass Container as a palette loader, is now the finished ware manager responsible for supervising the work of more than two hundred employees.

# Salem's Not-So-Little Revolution

*When I came here in 1977, we had thirteen machines; now, we have four shops and five machines. Of course, the glass industry has changed over the years. At one time it was a shrinking industry. Plastic hurt. A lot of glass manufacturers closed. There used to be a lot in New Jersey, but now there aren't too many—only a couple are left. For example, Gayner Glass Works used to be right across the street from us here.*

Anchor survived, Pritchett believes, because it went to bigger and faster machines. Some machines, for example, can make three bottles at one time, whereas most machines make two bottles at one time. Many years ago, glass was blown by hand, and at its peak, the plant on Griffith Street employed 2,500 people and ran twenty-five machines. Anchor employed 1,500 when Pritchett came in 1977. Today the company has about 360 employees. "Today, we have bigger and faster machines that take fewer persons to operate them," said Pritchett. "Our goal today is to be a high quality, low cost manufacturer of a good product."

About 70 percent of the workers at Anchor Glass Container are Salem County residents, said Pritchett. However, some employees come from Maryland, Delaware and Pennsylvania. The plant operates seven days a week, twenty-four hours a day. Pritchett works six days and usually starts his day at 6:45 or 7:00 a.m. He ends the day at 5:30 or 6:30 p.m. He is responsible for 200 to 230 workers who work for him directly or indirectly.

## Glass Business Has Stabilized

"I think the glass business has settled down now," said Pritchett. "In fact, there may have been a little growth because of some of the negative publicity about plastic. In fact, we've had customers come back to glass who had gone away [into plastic]. One of the main reasons for the switch is that the cost of plastic, a petroleum-based product, has gone up as the price of oil has gone up." The cost of producing new glass containers is also based in part on using recycled glass. In New Jersey, according to Pritchett, manufacturers of glass like Anchor are required to use about 20 percent recycled glass in the making of new glass. "So, every bottle made here has about 20 percent recycled glass in it."

Anchor is very efficient, said Pritchett. "We package about 93 percent, with only about 7 percent breakage, and we recycle all the broken glass. We produce here about 500 tons of glass per day. That translates into

approximately 2,400,000 different bottles. Most of them are sixteen-ounce Snapple bottles." The plant also turns out ten- and twelve-ounce Polanner jelly jars for B&G Corporation.

What has kept Anchor in business in Salem, Pritchett said, is its ability to do more with less. "We're here and others are not there." There used to be two Anchor plants in New Jersey, he said, but the one in north Jersey shut down about ten years ago. "At one point, it came down to a choice between them and us as to which plant Anchor would shut down." Once, he said, Anchor had seventeen plants around the country; now there are seven.

Anchor has a plan by which the company encourages children of employees who attend college most of the year and have summers off to work at the plant in Salem. "The company encourages these students to come back and work here every summer while they're in college," said Pritchett. "My sons and daughters worked here summers when they were in college."

CHAPTER 6

# NONE SO IMPORTANT

First, let's debunk the fairy tale about the Jersey tomato. In almost every book where the Jersey tomato is described and celebrated, the story is told about prominent Salem County resident Robert Gibbon Johnson in 1820 eating a tomato in front of a jittery crowd that was certain the red globe from which Johnson took a bite was poisonous. I say bah! And, furthermore, humbug! If you believe that fable, then you have to believe that in the long history of the tomato prior to Johnson's supposed grandstanding—and we're talking centuries—no one in that crowd, most of whose roots were in Europe, had ever heard of, let alone seen or eaten, a tomato.

Sam Cox, writing in December 2000, stated that the Spanish explorer Cortez in 1521 encountered and almost certainly ate one or more tomatoes after conquering the Aztecs, who grew and ate them regularly.

> It is presumed that the tomato found its way across the Atlantic shortly after. The earliest mention of the tomato in European literature is…in 1544. He [Cortez] described tomatoes…and wrote that they were "eaten in Italy with oil, salt and pepper." Red tomatoes were said to be introduced to Italy by two Catholic priests many years later.

Andrew F. Smith, in his book *Souper Tomatoes: The Story of America's Favorite Food*, states that "tomatoes were grown and eaten in what is today the United States nearly two centuries before they became popular throughout Italy."

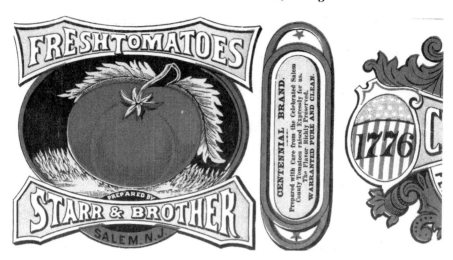

This is a label from the early days of food processing in south Jersey. *Courtesy of* Salem County Historical Society.

And Cox further reported, "In 1752, English cooks used tomatoes sparingly in flavoring of soups." And so forth.

Now fast forward to 1955 and John T. Cunningham writing in his book *Garden State*: "No single vegetable is more important to New Jersey than the tomato…[It] is economically significant to some 4,000 Garden State farmers. " In that year, Salem County ranked ninth out of 3,143 counties in the United States in tomatoes harvested for sale. That statistic takes on greater significance when one considers that Salem County, consisting of 338 square miles, is dwarfed by most of the other counties. Fresno County in California, one of the major growers of tomatoes, consists of 6,017 square miles. Of course, the tomato is also the official vegetable of New Jersey. If we continue to fast forward, it becomes apparent that while the tomato is still the official state vegetable, it is not as economically important to New Jersey or Salem County farmers as it once was. "In fact, the amount of acreage in the state dedicated to growing tomatoes has sharply decreased over the past decade," wrote George James in the *New York Times* in August 2002, "from 4,800 acres in 1991 to 3,600 in 2001." However, the latest data from the New Jersey Department of Agriculture for the year 2007 report that the number of acres devoted to the harvest of tomatoes for both processing and fresh market totaled 4,130 in the state. The total for Salem County was 857 acres. Of that number, 329 acres were devoted to harvesting tomatoes for the fresh market, more acreage than in any other county.

# None So Important

The headline over James's article in the *New York Times* reads "Despite a Squeeze from Outsiders, the Jersey Tomato Hangs Tough." James quoted a third-generation farmer in Hammonton: "I think the Jersey tomato market is healthy and can remain so, but it's important that growers understand we have a certain niche market." That niche, he said, is producing quality tomatoes for the region that are fresher, riper and tastier than the imports because they have less distance to travel to market. What makes the Jersey tomato so special? The secret, say the experts, starts with the soil and includes hot, dry weather."

The *Times* article goes on to state:

> *Michele Infante-Casaella, agricultural agent with the Rutgers University Extension Service in Gloucester County, says growing techniques add to* [the tomatoes'] *succulence. "The reason we're so hip on the Jersey tomato is because it's always been a vine-ripened product as opposed to those in other states," said Ms. Infante-Casella. The others, she added, "pick mature green fruit and then they unnaturally ripen it using ethylene gas, so they kind of stay a pinkish color." The growers in the New Jersey Tomato Council, who are concentrated in Atlantic, Cumberland, Gloucester and Salem Counties, carefully schedule their plantings and grow their tomatoes on stakes—out of the dirt—to prevent rot, using drip irrigation and plastic mulch to nurture them, all of which is costly. Once they pick the tomatoes, they ship them to the council's packing house in Cedarville, in Cumberland County, where they are sorted by size and color.* [During] *the growing season, July through October, the Jersey tomato will still be fresher than the imports. "Our advantage is* [that] *we can pick them while they're ripening, put them in a box and have them to stores that afternoon or the next morning," said Al Murray, director of markets for the New Jersey Department of Agriculture.*

# HOW IT WAS

In the beginning, during the American Civil War, the tomato was harvested in Salem County and the state for the primary purpose of putting it into a bottle or can. Mary B. Sim believes the first cannery in Salem County commenced operation in either 1862 or 1864. It was conceived by Theophilus Patterson, Richard B. Ware and Charles W. Caspar. Their business was short

lived, however, lasting only one year. According to Sim, the men had trouble recruiting women to work in "a factory of this kind." She did not explain exactly what turned off the women. The second factor was simple: "The price paid [farmers] was $0.25 per basket, equal to $12.00 per ton, and very few [farmers] would grow [tomatoes] for that price." Messrs Patterson, Ware and Caspar sold the cannery to James K. Patterson (perhaps a relative of Theophilus) and Ephraim J. Lloyd. Opening at about the same time was a cannery operated by Owen L. Jones. He first produced cans of his Trophy tomatoes out of a cannery on Church Street in Salem city. According to Sim, Jones's cannery boasted the highest reputation of any cannery in the county. Presumably, the only other one at the time was that owned by Messrs Patterson and Lloyd.

Andrew Smith, in his book, recalls the time later in the nineteenth century when "wagons and carriages of every description filled the roads on their way to the canneries. The roads were virtually painted red with squashed tomatoes that fell from the wagons." He goes on to describe how it was in those bygone times:

> *The most profitable crops of tomatoes in New Jersey were grown in Salem County. In most of New Jersey, an acre of good land yielded about nine tons of tomatoes. At first, many Salem farmers produced fifteen to twenty tons per acre, but over time this decreased. Originally, farmers received twenty dollars per ton, but by the end of the 1880s they were paid six dollars per ton. Salem farmers produced phenomenal crops in 1886 and 1890. Small factories packed two hundred thousand cans of tomatoes: larger ones, a million. One canning establishment in Salem manufactured almost two million cans, generating $150,000 in income. Several large canneries in Salem packed five million cans annually.*

One of the most successful canneries of the last decade of the nineteenth century and the first decade of the twentieth century was operated by Samuel Lewis Kelty, whose farm and cannery were on Beasley Neck Road in Quinton. The tomatoes grown on the Kelty farm and handpicked by twenty-five women were mostly of the "stewing type," according to Mary Sim. "Attention was given to cleanliness and careful supervision of the whole process of canning, for Mr. Kelty 'wanted his fruit to be of the highest quality.'" The label Kelty chose for his canned tomatoes was Defy the World. Sim does not explain why that name was chosen and what significance it had. Perhaps with his label Kelty was thumbing his nose at other, lesser

canneries in the county. Kelty sold his first one thousand cases of stewed tomatoes to Wilkinson & Gaddis in Newark. As the nineteenth century eased into the twentieth, Kelty bought a new conveyor belt that made life easier for his peelers. The number of workers increased to forty, and according to Sim, "business was good."

One day in 1896, Henry J. Heinz conceived fifty-seven varieties of products for his company. He didn't know then what all those fifty-seven varieties might be, but one of them turned out to be ketchup, and ten years later, he built a plant on Griffin Street in Salem city to produce it. Actually, for the first two years, the plant turned out mostly tomato puree, but eventually, thousands of bottles of Heinz ketchup were produced every day by a workforce that soon totaled more than three hundred men and women. Sometimes you can't get enough of a good thing. Just as Salem County tomato growers were getting used to and rejoicing over sales to H.J. Heinz, the P.J. Ritter Company opened its own ketchup—or catsup—plant on the bank of the Cohansey River in Bridgeton. The year was 1917.

# Out of the Lab

One day in 1897, Arthur Dorrance, who had acquired a controlling interest in the Joseph Campbell Preserve Company in Camden, appointed his very bright twenty-four-year-old nephew John to work in the company's laboratory. It wasn't considered an important position, and Arthur paid his nephew $7.50 a week. Not important? The young Dorrance emerged from the lab one day and announced to his uncle that he had discovered condensed soup by finding a way to remove water from an existing can of Campbell's soup. The volume of the can was reduced from thirty-two ounces to ten ounces, and the price paid by the consumer could be reduced from $0.34 to $0.10. Arthur showed his appreciation for what turned out to be a monumental discovery by increasing his nephew's salary by a $1.50.

The discovery not only changed the course of Campbell soups but also enriched the lives and bank accounts of Salem County farmers growing tomatoes. In 1900, the company sold seven million cans of soup; by the early 1920s, the number had ballooned to eighteen million. Of course, not all of the soup sold was tomato, just most of it. Ten years later, life got even better for both Campbell's and Salem County tomato growers.

Andrew Smith tells how:

*During the 1930s the tomato was king at the Campbell Soup Company. From late August to mid-October, all other soup production halted for making tomato soup. During the peak season Campbell's Camden plant produced ten million cans of tomato soup per day! In 1935 tomato soup accounted for almost half of Campbell's total annual soup volume. Subsequently, tomato-related products declined as an overall percentage of the Campbell budget. The tomato was never again Campbell's supreme product as it had been during the 1930s. However, tomato soup remained Campbell's largest-selling soup. In 1970 Campbell's president, William B. Murphy, proudly announced, "We think we know more about the tomato than anyone else in the world."*

## Salem Farmers Get in Line

During those months when Campbell's soup production line was devoted to tomato soup, many, perhaps most, of the trucks laden with tomatoes that lined up at the East Camden processing plant came out of Salem County. One of those trucks was driven by Ed McNemar, a resident of Woodstown. McNemar, who died in 2005, described the routine in my book *Tending the Garden State*:

*Truckers could spend the better part of a day or night standing in line at a cannery waiting for their tomatoes to be offloaded. "I've been in lines that were, literally, miles long," McNemar said. It was not unusual for trucks to be stretched up and down most of the streets of East Camden waiting their turn at one of two Campbell Soup Company plants. "If they shut the gates at night before you got in, you had the choice of coming back in the morning and getting at the end of the line or staying put and sleeping in the cab of your truck." McNemar remembered a time when his wife-to-be accompanied him on a run to Campbell's Soup. "They closed the gates before I could unload my tomatoes. I didn't want Doris to spend the night with me in the cab, so I put her on a bus for Salem and home." When the same long lines included both trucks whose tomatoes came from a [Campbell's] contract farmer and trucks hauling tomatoes being sold on the open market, McNemar said, the cannery usually would unload the contract farmers' trucks first. On occasion, when the crop was beyond bumper and the processor couldn't handle all the tomatoes in all the trucks,*

*those vehicles carrying open market tomatoes might stand in line for days until their tomatoes turned to mush. In such cases, the drivers would take their baskets back to the farmers and the mush would become fertilizer.*

# AND NOW?

Two years ago, in 2009, the Campbell Soup Company, for the first time since John Dorrance discovered how to make condensed soup, announced that it was making available to the American public specially cultivated tomato seeds. According to the company's press release, "The effort is part of Campbell's goal to grow more than one billion tomatoes across the country and to support American agriculture." The press release gave credit where credit was long overdue:

> *The tomato seeds themselves also have a rich heritage. Campbell began growing tomatoes from its own seeds on New Jersey farms in the 1930s. Those Jersey tomatoes were renowned for their rich taste and texture, so much so, that when truckloads were delivered to the Campbell facility in Camden, city residents followed and picked up fallen tomatoes from the streets.*

Ed McNemar, who trucked tomatoes to Campbell's East Camden plant, remembered a morning after a night spent in the cab of his truck when a boy asked if he could have one tomato. McNemar said yes, but when he looked in the rear view mirror of the truck, he saw the boy wheeling away a wagon-load of tomatoes.

The 2009 press release quoted Eric Christianson, business director for Campbell's condensed soup:

> *Campbell's tomato soup holds a special place in American culture and American cupboards because it's a food people know is made from goodness.* Through our Help Grow Your Soup *initiative, we are reminding people about the special care and pride that goes into cultivating the farm-grown ingredients in our soups by connecting them to the seeds, which is where it all starts.*

Just last year, Rutgers New Jersey Agricultural Experiment Station (NJAES) again touted the very popular Ramapo tomato, which had been developed in 1968 by NJAES and been resurrected as seeds available to gardeners in

2008. According to an article in the *Atlantic City Press*, "The Ramapo tomato has been well received by gardeners yearning for the original Jersey tomato taste." Salem County residents interested in purchasing Ramapo tomato seed may do so through the NJAES website at www.NJAES.rutgers.edu.

## Latitia Duell Camp Remembers

Latitia Duell Camp has lived in the same house (circa 1860) on the same farm at the end of the same long dirt lane for all of her ninety-five years. She shares the house off Route 40 in Pilesgrove Township with her daughter, Sue, and son, John, who tend more than one hundred head of sheep on the Camp acreage and grow hay on another one hundred rented acres in Gloucester and Salem Counties. Latitia is the author of *Days on the Farm*, a collection of verses that reveal the life she has lived. The opening verse

Latitia Duell Camp holds a jug that is nearly as old as she is at age ninety-five.

begins, "Life is made of tougher stuff than day dreams, motorcars and bridges." As a girl in the early 1930s, she preferred working in the fields with the men—the "tougher stuff"—to household duties. "I didn't like dust." She performed nearly all the tougher stuff as well as the men, except for plowing. "I called the men plow jockeys. They were able to step in line with the horse's feet. I couldn't follow in the horse's footsteps; I fell down a lot." Recently, she recalled what it was like nearly eighty years ago to bring in the annual hay crop.

## How Blows the Wind?

Latitia's father and grandfather—and other farmers who grew, mowed, bundled and stored hay—kept their senses tuned to the weather. A strong breeze out of the east or south in the morning might portend rain or at least excessive dampness, and the hay had to be pretty dry for bundling. If the weather was good, or at least promising, work in the field began at around 10 o'clock, when the cut hay lying on the ground would have had time to dry out from overnight dampness. Her father would "drive" the dump rake drawn by a single horse. The dump rake was ten to twelve feet wide and had a set of curved tines mounted on a frame set between two large wheels. Latitia's father, sitting on a seat mounted above the frame, worked a lever that lifted the rake teeth when they were full of hay and deposited the hay back down on the ground in bundles of about eight feet in length.

Latitia's task then was to pitch the hay bundles onto a wagon using a long-handled, three-tined hay fork.

> *The hay smelled so sweet. It was wonderful. To begin with, I rolled over the hay bundles so that the bottom of the bundles, which had become damp overnight, could dry out. It took a long time. So, now you had all these bundles—these haycocks. The next day you had to turn the bundles over again to let the bottom dry out. Then, my father would look at the sky and sniff, and, if he liked what he saw and sniffed, he would decide it was time to bring in the hay. Again, we would start at about 10 o'clock in the morning. The wagon had side shelves but was otherwise open. Two horses pulled the wagon, and they had to be well-trained because no one drove them. I would work one side of the wagon, pitching haycocks on to the wagon, then work the other side. Eventually, the bundles filled the bottom of the wagon up to the shelves on either side. Then you pitched onto the shelves, and the rails of the wagon held the hay in place. The*

*man on the wagon would make sure that the bundles were level. I never stayed on top of the wagon; I didn't want that hay down my neck. When you got to the end of a row, you had to turn the horses; otherwise, they'd head back to the barn.*

*So, we had a load of hay. We left the field and took the loaded wagon to the barn. We had a three-story barn at that time, before a hurricane blew it down. Using pulleys, we would bring down the hay fork that would close over several hay bundles at one time. A horse pulled on a rope that raised the hay fork to the hay loft; then, someone—often one of the children—would pull on another rope that would open the hay fork and deposit the hay bundle.*

## *"You Got Muscles"*

Latitia performed all the tasks described when she was a teenager, and it was very hard work. "You got muscles," she said. At the time, the Camp family owned and farmed about eighty acres. "That was about all one man and his family could handle in those days," she said. In addition to the hay, the Camp farm grew corn and potatoes. Also, Latitia's grandfather had cows. In addition to selling the milk produced by the cows, he made butter during World War II when butter was scarce.

Today Route 40 is a busy highway connecting east and west Salem County and providing a not-so-fast way to get to Atlantic City casinos and beach resorts. Latitia remembers when the highway—"an old Indian trail"—was a dirt lane, and her family, as well as other farmers along the way, kept it relatively smooth and free of ruts by occasional scraping.

In her book *Days on the Farm*, Latitia has included the verse "Identity," which pretty well describes the generations of Camps that have tended the farm at the end of the long lane:

*We are the Earth people fashioned from the dust of stars, in harmony with the wind and weather, linked to the designs and customs of the past, but we are still parts and hopes of the future. We are keepers of the animals, the plants, the streams and the forests. We are teachers and leaders of coming generations—earth people reaching for the stars.*

# LARRY ERDNER REMEMBERS

Fifty years ago, Larry and Rick Erdner incorporated as Erdner Brothers. "In 1960, we had seven trucks and a dream," recalled Larry. The dream included hauling freshly picked tomatoes into local processing plants and hauling out tomato products such as ketchup and soup in cans or bottles. The plants were H.J. Heinz in Salem, Del Monte in Swedesboro, Campbell's Soups in Camden and Ritter and Hunt's in Bridgeton. The brothers dreamed big. Four years later, in 1964, they built a sixty-thousand-square-foot terminal on Elm Street in Woodstown. "Mostly, we were transporting and storing the finished products from the processors," said Larry.

Larry Erdner's trucks have been the prime movers of Salem County agricultural products to East Coast food processors and markets.

He continued:

*I remember when Del Monte, which was putting up asparagus and then tomatoes, decided they wanted another crop to fill in between asparagus and tomatoes so they could keep the help busy. They decided on zucchini. So, they got farmers to grow zucchini, and they agreed to pay them by the pound. Well, you know, zucchinis; they can grow to baseball bat size. Del Monte had just these little field boxes, and two or three zucchinis would fill one of those boxes. And the zucchini seeds were so big there just wasn't much Del Monte could do with them, so they ended up throwing many out. Del Monte took a big hit on zucchini that year.*

Although the H.J. Heinz processing plant was located on Griffin Street in Salem, the company bought many of its tomatoes from farms in southern Delaware. The reason, according to Larry, was that tomato plants on farms in Delaware, being farther south than farms in Salem County, were ready for harvest earlier. "Heinz could get a two-week jump on tomatoes by going into Delaware," he said. "We would bring twenty or thirty trailer loads of tomatoes a day out of Delaware." Erdner Brothers also supplied Heinz with glass bottles from the Woodstown storage facility that Heinz used for its ketchup. "I could never understand why Heinz imported glassware when Anchor Container Corporation was right next door. I asked them once, and I was told that it was cheaper for Heinz to have bottles shipped from Pittsburgh [and stored in the Woodstown facility] than to buy them from Anchor. Of course, that didn't make any sense to me."

"We needed to have work for our people year-round, so, for example, a lot of our business with Campbell's was trucking in frozen vegetables for processing, for example frozen green beans from Seabrook Farms in Bridgeton and frozen carrots from Smyrna, Delaware."

## Changing Times

"Now, if I look back, there's almost nothing Erdner Brothers is doing today that we did years ago when we were hauling tomatoes and such," said Larry. "When their plant in Camden finally closed down, Campbell's still had a plant in Salisbury, Maryland, where they made TV dinners. We would truck Pepperidge and Mrs. Paul's down there [to Salisbury] and pick up the TV dinners and then take all three products to outlets like Acme. We were carrying twenty-five or thirty loads a day. Then they moved the Salisbury plant to Nebraska, and I didn't want to go that far."

When the local food processing plants like Heinz, Campbell's, Ritter and Del Monte closed, the Erdner brothers went in search of other customers not associated with food products. Now, for example, the company hauls and stores for Mannington Mills. Other customers include out-of-state plants operated by Michelin Tires and General Electric.

Today, the dream of fifty years ago is still very much alive, but not the same. Erdner Brothers owns sixty tractors, two hundred trailers and another larger warehouse in Swedesboro. Oftentimes, Larry Erdner wishes his trucks were still hauling tomatoes, asparagus and zucchini. "Like Thomas Jefferson, I much prefer an agrarian society."

# LONG AGO IN MANNINGTON

The township, which today encompasses forty square miles, was named for the Lenape Indian chief Maneto. It may be best known not for John Fenwick's buried bones but for the bones of an ancient mastodon unearthed by Joseph R. Hackett while he was digging for marl in 1869. The head of the ancient creature was said to weigh more than four hundred pounds and measured two feet and ten inches across and six feet long. Hackett's find was turned over to the state to lie in state.

Today's township includes what was, 250 years ago, the village of Mannington Hill, where the land rises south of Route 45 and west of County Road 669. According to historians Henry Howe and John W. Barber, one night during the American Revolution, "a small party of the enemy" broke into the home on the hill belonging to the Ambler family: a father, mother and two daughters, all of whom were in bed at the time. "The party, on entering," wrote Howe and Barber, "commanded [the family] to keep perfectly quiet and not to lift their hands from under the bedclothes on pain of being murdered. After rifling the rooms of the valuables and such articles as they could conveniently carry, they decamped."

The historians do not further identify the "small party of the enemy," but it is more likely that it was a group of local Tories rather than a detachment of British or Hessian soldiers.

Another story from the American Revolution concerns young Edward Hall, the son of William Hall Jr. and a Quaker. One day when Edward was on his way to join the militia, he met friend and fellow Quaker John Reeve, a pacifist who was on his way to Meeting. Cushing and Sheppard recounted their exchange:

"Edward, I notice thee is dressed in soldier's clothes."

"I am. I came to the conclusion it would be right for me to fight for my country."

"If thee thinks it is right, it may then be thy duty. I hope God will be with thee. I bid thee goodbye."

Edward was later disowned by Salem Quarterly Meeting, and the men did not see each other again until after the war.

## Good Grain and Good Drink

Since the time Fenwick and other newly arrived English families cleared much of the land of oak trees, Mannington has boasted prime agricultural acres. In 1830, the township reported the best agricultural production of any in the state. Primary crops were wheat, corn, oats and potatoes. Most farm families made their own hemp and woolen goods. According to Howe and Barber, "Mannington has long been noted for its fruit, which grows luxuriantly, and for the fine varieties of ornamental trees." A windmill built on a hill in a section of the township called Claysville manufactured flour and feed for animals.

The early population of Mannington may have consisted of super industrious and great farmers, but they also liked their occasional—well, maybe not-so-occasional—alcoholic beverage. In the early and middle years of the nineteenth century, the manufacture of liquor from apple cider was a thriving business. The township had seven or eight distilleries operating at the same time.

In the latter decades of the nineteenth century, township landowners paid a poll tax of $489, a school tax of $410 and a county tax of $3,898.

# Long Ago in Lower Alloways Creek

The township is best known, of course, for the terrible events of March 21, 1778, when British soldiers and local Tories broke into the William Hancock house and murdered the elderly Hancock and most of the sleeping American militiamen. However, that section of the township known as Hancock's Bridge was also a primary port for Salem County, with ships bearing exports and imports going up and down Alloways Creek.

The township was only sparsely settled well into the nineteenth century, and one of those residents was Ebeneezer Harmer. He had the good fortune,

This is how the Hancock house in Lower Alloways Creek looked before restoration. *Courtesy of* Today's Sunbeam.

according to local historians, to marry a lady known only as a "woman of property." Of course, the "woman of property" was not further identified, but Mr. Harmer, who evidently had little or no property and other collateral of his own when he wed, benefitted considerably from the marriage and had a section of the township named for him: Harmersille.

## *Not So Dear Old School Days*

"The subject of education was one that early entered into the minds of the people of the Township," according to Cushing and Sheppard, and no wonder. In the early decades of the nineteenth century, the very sparsely populated township was divided into seven school districts under the direction of five school trustees. "The school houses, which were generally poor affairs," wrote Cushing and Sheppard, "were only kept open during the winter season, and the child who wished more than the customary winter quarter generally had to go elsewhere to get it." The "elsewhere"

was not further defined, except that Cushing and Sheppard stated that "the few wealthy residents sent their children away to some boarding school to be finished, but that was the exception and not the rule."

As is still true, the schools, their teachers and the students of that time depended as much or more on local taxation than on state allotments. "The money that was raised by [local] tax was first apportioned by the town superintendent," wrote the historians, "and then the trustees apportioned to each scholar attending his share of said public money, and the balance of the amount needed to pay the expenses of said scholar was paid by the pupil himself [read parents or other relatives and friends]." Since no mention was made of salaries paid teachers, it might be assumed that the "scholars" paid the teachers from whatever tax money was allotted them. And it wasn't much.

Cushing and Sheppard wrote:

> *In looking over some old documents in our possession, we find that the amounts charged the scholars for tuition from the years 1839 to 1850 was two dollars per quarter, and the amount of Township tax for the same time was often not over two dollars per year; this, with the interest arising from the surplus revenue and school fun, making about four hundred dollars per year.*

Go figure!

According to the historians, the schoolhouse in Hancock's Bridge was considered "the best" in the township and possibly the county, in large part due to the energy, wisdom and perhaps financial support of trustee Thomas Shourds.

## *A Bridge Anyone?*

In the year 1684, the Salem Monthly Meeting of Friends agreed to have a meetinghouse built on the north side of Alloways Creek for the convenience of Friends residing in Lower Alloways Creek. The building was completed the following year. There was only one problem, according to the historians: "The greater part of the members resided on the south side of the creek, and there being no bridge at that period, they were put to great inconvenience in getting to meeting." Of course, a bridge was later constructed.

# "Soil So Excellent and So Fertile"

That's how John T. Cunningham described New Jersey in his book *Garden State*. Then he reported how New Jersey farmers nearly ruined the land by poor management until toward the middle of the nineteenth century, when they discovered marl and limestone and spread them on their acreage. "The land grew rich and green again," he wrote. Rich indeed! By the middle of the twentieth century (Cunningham's book was published in 1955), New Jersey farms were producing "the highest gross farm income per acre in the nation." The year 1953 was the "best year in New Jersey agricultural history," according to Cunningham.

How about now? How about Salem County?

It's nearly impossible to come by current hard data concerning the state of agriculture in Salem County. Most statistics regarding agriculture in Salem County—or anywhere else in New Jersey and the country for that matter—come from a census conducted every five years by the U.S. Department of Agriculture (in years ending with the number two or number seven). While hard data for 2007 are available online (see Selected Agriculture Statistics for 2007), analysis of the data and commentary regarding the statistics is in 2011 still mostly predicated on the 2002 census.

That most current analysis concludes that "Salem County's largest single land use continues to be agriculture. Aerial surveys show 42% of the County's land as agricultural." Perhaps the best news in the report is that the 2002 census "shows a continued gradual growth in farming activity in Salem County from 1997 to 2002. The number of total farms increased 5%

*Above*: Salem County honored its residents who had been farming for fifty years or longer. John Robinson was one of the Half Century Farmers. *Courtesy of* Today's Sunbeam.

*Below*: Nathan Mattson was another Half Century Farmer lauded for his contribution to agriculture. *Courtesy of* Today's Sunbeam.

# "Soil So Excellent and So Fertile"

*Above*: A farmer's tractors are ready to roll for a new season.

*Below*: The land is prepared for planting.

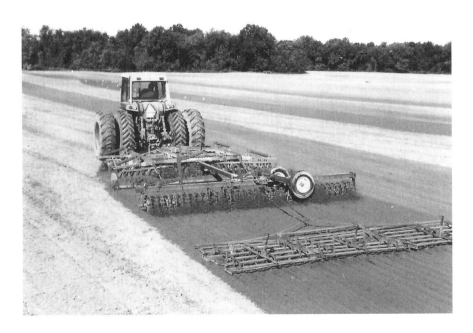

*Above*: A new season begins for Jersey tomatoes.

*Below*: Early spring tomatoes are protected against the weather.

# "Soil So Excellent and So Fertile"

*Above*: Spinach is an important cash crop for Salem County farmers.

*Below*: Spinach is harvested for the fresh market.

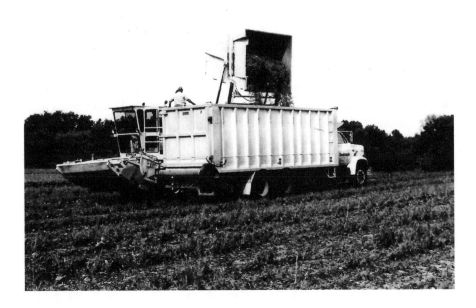

from 716 in 1997 to 753 in 2002." By 2007, as noted in the accompanying chart, the number of farms had increased to 759, a modest increase but significant. The good news is due in part to economic conditions that cooled off residential developers and to Salem County farmers' commitment to land preservation (see chapter on land preservation).

While Salem County farms and farmers are holding their own (farm acreage in New Jersey dropped from 1.8 million acres in 1950 to 0.8 million acres in 2000), primary crops harvested by Salem County farmers have changed significantly. The report for 2002 stated that soybeans were the top crop, with 18,240 acres planted. However, this figure is considerably below the number of acres devoted to soybeans in the ten previous years. For example, the New Jersey Agriculture Annual Report for 1998 stated that Salem led all other counties in the state when it came to soybean harvests from 1992 to 1997. For example, the soybean harvest in Salem for 1992, ten years before the latest claim, was 29,200 acres. In 1997, it was 27,000 acres.

The 2002 report based on USDA data concluded: "Agriculture is a major component of Salem County's economic health and social fabric. While over time the economy of the County has grown to encompass other industries, farming has remained the cornerstone upon which the County developed."

## Looking Ahead

"Looking to the future, the major issue for agriculture in Salem County is water," predicted David Lee, Salem County cultural agent. The question, he said, is whether we will have enough of it in the future. "You have more people moving in, and so they're drawing more water out of the existing aquifer for residential and commercial uses." The problem that could develop then, he said, is whether the county's farmers will continue to have enough ground water to irrigate their crops.

Aside from that problem facing tomorrow's farmer, the future for agriculture in Salem County remains promising, Lee said, albeit the direction(s) may vary from the past. For example, he envisions Salem County farmers producing more for the fresh market and less for food processors. The canneries of old are all gone anyway, so there are fewer food processors available to take Salem County produce.

The influx of new homeowners may reduce the water supply, Lee said, but they also are potential buyers of fresh produce. "We [Salem County farmers]

# "Soil So Excellent and So Fertile"

*Above*: Dairy cows graze along a country road but not in the numbers seen in past decades.

*Below*: Farmer Joseph Doak installed the first milking machine in New Jersey that allows cows to milk themselves.

have to get more into that direct consumer market." Already, the number of local farmers engaged in direct marketing has increased. "They're supplying farm markets and small stores managed at the local level," said Lee. "Lots of studies show that people like to buy their produce fresh; they like to support local farmers."

More and more Salem County farmers may grow more grain, said Lee. The reasons are several, he said. In the first place, grain can be grown and harvested with a minimum amount of labor, which used to be one of the major agricultural expenses. Also, many of the farmers who have been working hard for decades are inclined to grow crops that are perhaps easier to plant and harvest. "Furthermore, grain prices over the last few years have been high," Lee said. "This year [2010–2011], for example, we had a lot of wheat planted because the price for wheat was very high." Farmers can react rather quickly to the marketplace by deciding to grow grain, said Lee.

There are far fewer dairy farms in the county now, Lee said, one reason being that caring for dairy cows and milking them two or three times a day is very hard work, and many of today's farmers are of an age when they don't want to or can't expend that much time and energy. However, he said, Joseph Doak, whose dairy farm is on the Woodstown-Alloway Road, has installed the first milking machine in the state that is activated by the cows themselves. Doak has approximately sixty milking cows, and they come into the barn two or three times a day and become attached to the automated milking machine and give their milk. "I think we'll see more and more of these robots," said Lee. "Farmers have come to rely more and more on technology, and why not? Young people today, in particular, don't want to spend all that time, and why should they if technology can help."

## AGRITOURISM AND COMMUNITY SUPPORT

Agritourism is becoming more important. Farmers open up their operations and offer their produce directly to the public. "People want to see how a farm operates," Lee said. The county has a Department of Public Information and Tourism, and Lee is convinced that tours of farming operations will become even more prevalent in the future. "Agritourism is already big in some northern counties," Lee said, "and it will continue to grow here in Salem County."

Another major development for the future is community supported agriculture, predicted Lee. Farmers, for example, may sell a share to a family for $200 or $300 that entitles them to go to a farm-fresh market in season and get a basketful of vegetables and fruit produced by that farm. In some cases, family members might, themselves, pick ripe fruit off the tree or fresh vegetables out of the ground. "That's a way to get people to the farms and to get that direct

consumer dollar," said Lee. In some cases, family members might actually work in the field, cultivating or performing other farming chores.

## SOD FARMS AND NURSERIES BECOME MAJOR INDUSTRIES

Perhaps the most dramatic change in agriculture in New Jersey and Salem County, other than the considerable decline in the acreage devoted to tomatoes (from 6,300 acres harvested statewide in 1992 to 3,300 acres in 2002), is the dramatic increase in acreage devoted to and cash receipts from greenhouses, nursery stock and sod. In 1992, for example, cash receipts from greenhouses, nursery stock and sod amounted to $181,755,000 for the state, and the cash receipts from all field crops, vegetables, fruits and berries totaled $271,633,000. Ten years later, in 2002, cash receipts from greenhouses and more totaled $364,822,000, while receipts from all field crops and more totaled $315,153,000. This significant change in agriculture and the landscape has impacted Salem.

Nurseries in Salem County and New Jersey have increased significantly to meet the demands of new and expanding housing developments. Note that shrubs are in containers ready for planting by homeowners.

In the past several decades, an increasing number of farmers have grown sod, trees and shrubs instead of tomatoes, corn and peaches, and an important reason why is that they can make more money per acre selling sod than tomatoes. Earl Ervey of Woodstown, who served on the New Jersey Board of Agriculture from 1989 to 1993, said the yield per acre for nursery stock vis-à-vis fruit or vegetables is huge. He was general manager of Medford Nursery in Burlington County for twenty-four years, and he said the nursery could post an average annual income of $10 million from nursery stock grown on two hundred acres. "There is no comparison between that income and what a farmer could earn by growing vegetables or fruit on those same two hundred acres."

## Growing Trees in Containers

What has changed for the nursery business to make it even more efficient and profitable, Ervey said, is the growing of small trees and shrubs in containers rather than in the ground. In decades past, a homeowner wanting to plant a couple of small trees or shrubs on his property would go to a nursery in season, and the nursery would dig up the individual trees and bushes and wrap them in burlap. Today the consumer can go to a nursery and pick out his trees and shrubs that have been grown in containers, and those trees and shrubs are ready to be carted home and planted. "The container development was focused, of course, on the cash and carry retail center or market," said Ervey. Now the homeowner can go to places like Walmart and Lowe's and purchase trees and bushes in containers and take them home in their vehicle, and if they choose, they can let the trees or bushes sit in their containers for awhile until they are ready to plant them.

"What has changed then," said Ervey, "is the ease of selection, ease of purchase, and the ease of handling and planting. Container production is what has made all this possible."

## Sodding Backyards and Stadiums

About one thousand Salem County acres that perhaps were once planted in tomatoes or grazed by dairy cows now grow sod for your neighbor's backyard or left field in Yankee Stadium. The owner and caretaker of those acres is

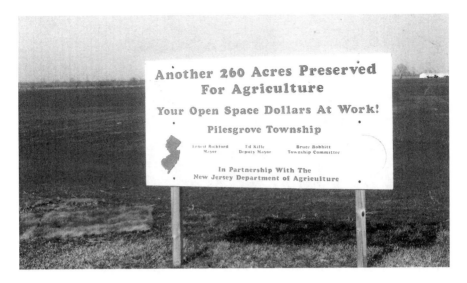

East Coast Sod and Feed has preserved these acres on U.S. Route 40 and an equal number elsewhere in the county. Salem County leads the state in number of farm acres preserved at more than twenty-eight thousand.

East Coast Sod and Feed, which has been located on Auburn-Pointers Road in Pilesgrove Township for the past ten years. According to David Giordano, branch manager, five hundred of those acres are preserved.

Although the dragging economy in the past six years or so has reduced demand for residential sod for East Coast and other sod farms, Giordano said home landscaping is a small part of East Coast business.

Actually, according to Giordano, most of East Coast's customers are one hundred to five hundred miles away. The customers include the new Yankee Stadium and several minor league stadiums, he said, and "high-end" golf courses in north Jersey and New York State—"Where the money is," he added.

One reason that East Coast and other New Jersey sod farmers do so well, Giordano said, is because of the state's sandy soil. The sand provides good drainage. East Coast Sod and Feed employs twenty people full time and another thirty part time. The season for the business is nine months, March through November.

## TOASTING WINEMAKING

The number of vineyards and winemakers in New Jersey has skyrocketed in recent years, and today New Jersey ranks fifth among states in wine production

The Auburn Road Winery in Pilesgrove is one of a number of new vineyards and wineries in New Jersey.

and also fifth in wine consumption. One of the more recently established vineyards and wineries is Auburn Road Vineyards in Pilesgrove Township. The first two of sixteen acres were planted in May 2004. Scott Donnini, one of the owners, described how he and wife Julienne and other men and women, all of them brand new to the business, accomplished the task: "We planted two rows a day, everyone on their knees with yardsticks to make sure the plants were exactly six feet apart. We covered over the dirt by hand. We felt like farmers." Previously, they had lived in Philadelphia.

Auburn Road Vineyards has been awarded medals for its wine by the Finger Lakes International Wine Competition. The wine bar is open Fridays from 4:00 to 8:00 p.m.; Saturdays from 12:00 to 9:00 p.m., and on Sundays from 12:00 to 5:00 p.m. The wine bar features live music on Saturday nights.

# Long Ago in Alloway

Once a part of the long-defunct Upper Alloways Creek and once known as Allowaystown in the late eighteenth and early nineteenth centuries, Alloway Township had its new beginning as a township in 1884. It was about that time that the historians Thomas Cushing and Charles Sheppard in 1883 paid Alloway a great compliment when they called the township "one of the most enterprising towns of its size in Salem County." The enterprising began in

The general store in Alloway was built in 1838.

earnest about fifty years earlier when the Reeve brothers decided to build ships—big time. Historian Joseph Sickler, in his history of the county, referred to the Reeve Brothers Shipyard as "one of the largest shipbuilding plants in the Union." They were talking about all of the United States of America! Sickler, in his book, quotes an article printed in the *National Standard* of 1844: "Glory to little Alloway. She has grown upon her banks and bourne [*sic*] upon her bosom some of the finest merchantmen that ever floated on the Delaware."

The Reeves—Josiah, William and Emmor—started out in the early 1820s using water power generated by Alloways Creek to run their sawmill and gristmill. In about 1824, Josiah decided that the shipbuilding industry in Philadelphia could use and therefore buy from the Reeves planking cut from the oak trees that abounded in the area. Six years later, the Reeves built a second milldam that created a 150-acre pond, thereby boosting water power to run their existing mills and to produce even more planks for Philadelphia shipbuilders.

In the book *Alloway Remembers*, Arthur Channing Downs Jr. described how the Reeves' shipbuilding industry began and prospered:

> About 1832 the Reeve Brothers began to try their hands at shipbuilding. At first they built sloops…for their own business use. The well-known superiority of Salem County white oak that they used soon began to bring orders from others for their ships. As time went on they began to attempt larger ships, including ocean-going steamers. The ships that came from their quarter-mile-long shipyard along Alloway Creek played a part in many aspects of the life of our growing nation. They built sloops that carried work-a-day cargoes to and from Philadelphia; they also built many of the canal boats of the Schuylkill Navigation Company, several of the side-wheel steamers…and the swift-sailing bark Pons of 1841,

*Left:* It is hard to imagine today that the Reeve brothers launched ships down this creek to the Delaware River. Of course, the launches were powered by a surge of water from the lake in Alloway.

*Below:* This is the home of one of the Reeve brothers in Alloway. The brothers were shipbuilders in the nineteenth century.

*which some "Spanish gentlemen" found well suited to the slave trade. Reeve & Brothers' [ship] John S. McKim was the first commercial steamer in the United States driven by a propeller.*

Today's visitor to Alloway might wonder how the Reeve brothers were able to launch ships that eventually found their way into the Delaware River. Downs answers the question: "They accomplished this feat by hoisting the

floodgates of their large milldam; this raised the tide in the [Alloway] creek a foot or more, and the ship would be immediately launched and pushed to deeper water." The Reeves' shipbuilding business, at its zenith, employed about one hundred men.

Forty years after the glory days of shipbuilding, Alloway's population stood at 602, and it was still abuzz with activity. In the early 1880s, Cushing and Sheppard counted three general stores, two groceries, one hardware store, three butchers, four blacksmiths, three—count them—shoe stores, a hotel and two restaurants, a notary public and two physicians. A resident or visitor in the 1880s couldn't buy a sloop or probably even a sizeable rowboat, but he or she could hire a carpenter, buy a handsome chair for the parlor or contract for the services of the local conveyancer. A whatcer? you ask. The historians explain that the conveyancer is a master in chancery. Got it?

## JOANNE CATALANO REMEMBERS

Joanne and Michael Catalano started farming on Black Road in Mannington more than fifty years ago. They "retired" about nine years ago. Like most Salem County farmers, for the first twenty or so of those years most of their one hundred acres of farmland were planted in processing tomatoes from July through September. They didn't have to go far to sell them: Heinz in Salem, Ritter in Bridgeton, Del Monte in Swedesboro. Then, as Joanne told a *New York Times* reporter in 1992, "the [tomato processing] market in southern Jersey is gone." The processing plants closed.

Even when tomatoes were the principal crop, the Catalanos and other farmers planted and harvested other crops depending on the season, weather, disease and market—perhaps in reverse order. "You either adjusted or..." Joanne didn't have to finish the sentence. "For example, when we started farming in the late fifties, we planted 150 acres of asparagus." Why? Primarily because major processing plants like Seabrook Farms in Bridgeton, which *LIFE* magazine called the "biggest vegetable factory on earth," were buying and processing a lot of asparagus. "Later, we had to stop growing asparagus because of a disease that attacked the roots. Since at that time asparagus was our first spring crop, when asparagus became diseased and we no longer planted it, our season in those years just started later." Although the Catalanos no longer grew and cut asparagus for Seabrook Farms, they planted and harvested

Joanne Catalano looks through an album of farm pictures.

green beans for Seabrook. "Of course," Joanne said, "during this period when we were growing asparagus or beans or other vegetables, we were always growing some tomatoes."

## Planning Ahead

"Through the years, we, like all farmers, had to learn how to plan well," Joanne said.

> *Remember, we had to work with the weather, and she could be a nasty little girl sometimes. The weather didn't determine what you planted, but after you planted you just hoped the weather wouldn't hurt you. Also, as part of the planning, you had to figure it might take two or three years before you would see a return on your investment. I remember when we were raising green beans for Seabrook, they based the timetable for planting and harvesting on what they called heat units. In other words, they tried to calculate soil temperatures throughout the region that might determine when farmers in different parts of the region might be expected to plant and later harvest their crop. Of course, the system didn't always work. You might get a hot spell and everything converged at the same time.*

## *What's Changed?*

Perhaps the most significant change through the years, according to Joanne, has been relying less on hand harvesting and more on machine harvesting.

> *For example, we used to depend on forty to forty-five men to cut asparagus and pick tomatoes or whatever. When we got the harvester machine, we needed much less help. It was a godsend for us. It significantly cut down our costs. Of course, like all farmers, we were subject to whatever the contract price* [for our harvest] *was, and sometimes that wasn't particularly amenable with our expense schedule. Sometimes there was some fussing that went on here as we tried to make the job a little easier so we could get a decent return on our investment.*

The contract price was always subject to events and conditions local farmers could not control. "For example," Joanne said, "if the Carolinas got decent weather and their harvest came in early, well, you know what could happen then. The price paid here might be suppressed. On the other hand, if they had bad weather, then we might get a better price." She pointed out that modern techniques have greatly affected every farmer insofar as controlling the effects of weather and other conditions. "Now we have plastic tunnels that protect plants until the outside temperature warms up enough and plants will not be harmed. That means crops might come in two or three weeks earlier than they used to." Sometimes now, because of the plastic, Joanne said, local crops come in at the same time or even earlier than those in the Carolinas.

What are Michael and Joanne raising these days? "A little heck sometimes," she answers.

## LEE WARE REMEMBERS

Lee Ware grew up in a patterned-brick house in Elsinboro that had figured in Salem County history for 227 years before he was born. He has figured in county history for the past 40 or so years as a farmer, Woodstown High School teacher and coach and as a county freeholder, the last 6 years as director of the Board of Chosen Freeholders. The Ware family has farmed 150 acres of good ground. "Over the years, we raised every vegetable you can think of, even okra

Lee Ware is descended from a long line of men and women who have been active in Salem County agriculture and government.

one year. My brother [Clint] and I had to cut the okra with a knife every day, and, because of the stickers, we had to wear a long-sleeved shirt." Asparagus was for many years a major cash crop for the Ware family. Like many Salem County farmers, the Wares depended on the Heinz Ketchup plant in Salem city to take its harvest of tomatoes. "When the Heinz plant closed in 1977, I think Salem County agriculture was crippled." Crippled, perhaps, but like good farmers everywhere, when one crop or market fails, the Ware family started growing and marketing bell peppers. "We packed 1,500 boxes of peppers every day."

*When I was growing up, almost every kid in Salem County worked on a farm in the summer. I think even now every kid should spend at least one summer working on a farm. It would make them appreciate life. When I was a teacher in Woodstown High School, I would tell my students that, while farmers can't pay them very much, they can get a good tan and cool off in the irrigation pool in the afternoon. We hired hundreds of youths over the years to work on our farm. Mom would make lunch for the kids and give them cookies in the afternoon. Then, in 1999, my father [Preston] became ill and died; my brother, Clint, was stricken with ALS a year later. So, the year 2000 was the last year for peppers. Now, it's all grain— soybeans, corn and wheat.*

## Growing the County

For nearly forty years, the Wares have helped to nurture Salem County's historical ups and mend its occasional downs even as the farming family coped with changing food markets, ripples in labor pools and capricious

104

weather. Preston served on the Elsinboro Township Committee for twenty-five or so years and one year on the Board of Chosen Freeholders when it was a much larger board with one member from each municipality. Clint served on the Salem City Council for several years and then became a county freeholder in the mid-1970s, serving for twenty-six years until he became ill. Lee took over from his brother in the year 2000 and has served as a freeholder ever since. "So, it has been nearly forty years of consecutive Ware leadership in county government," said Lee.

Not only has Ware leadership been steady over four decades, but life in Salem County hasn't changed all that much during the same period, according to Lee.

> *For years, the county's population was around sixty-four thousand, and the latest census reported the population at about sixty-six thousand. Salem County is unique. Unlike residents of more urban counties, we can still vote for the people we know and trust. We are still primarily an agricultural county, number one in preserved farmland. Salem County is the last bastion [in New Jersey] in development. People live in Salem County for a reason. They like the slower way of life here. They like to drive down a country road.*

Lee recognizes that the county has in the past been under pressure to add more and more housing developments and that the downturn in the economy gave everybody just a little breathing room. "The fact that we have twenty-six thousand or so preserved acres helps." He gives credit to the county's master plan developed some years ago. Basically, it allowed for development along the so-called I-295 corridor and preserved most of the rest of the county for agriculture and open space. "There has to be a balance, and I think we have it," said Lee.

# BY ANY OTHER NAME IT SPELLED FREEDOM

Perhaps four or so miles south on a straight line from where Interstate 95 crosses the Delaware Memorial Bridge and descends into Salem County is a one-room school that should have either fallen down or burned down years ago; it's that sorry looking. It is also one of the last vestiges of a place called at various times Marlboro, Frog Town, Marshallville and Marshalltown. Today on the Salem County map it is Marshalltown, named for Thomas Marshall, an African American who owned about as much of the land as any other man, and it is a place where freed African Americans did as well or better than any other place in Salem County in the middle of the nineteenth century. The area acquired the name Marlboro because of the deposit of marl found in the vicinity. Marl, a kind of mud rich in nutrients, helped save depleted Salem County farms beginning in the 1840s. No one is quite sure how the name Frog Town originated, but the general consensus is that it was a derogatory term.

According to the 1840 census, Marshall, who not only was a landowner and speculator but who also owned and operated a general store, was one of 490 free black people living in Mannington Township. Ten years later, in 1840, he was listed as one of five black farmers. According to local historian Janet L. Sheridan, Marshall first bought land in 1831. "He continued acquiring land through 1856, accumulating nearly 100 acres in 10 parcels." Most of the parcels were in the area known as Marshalltown. "Though Marshall sold lots of land to other African-American-descended people," Sheridan reports, "he was not the only [black person] buying and subdividing land.

The Marshalltown School may have been the last segregated school left in New Jersey.

Deed records show that, in 1840, Perry Sawyer, a black man, purchased a one-acre lot from Samuel Seagrave, white, in 1836, just two years after Marshall's first purchase in this vicinity. Sawyer sold it to Samuel Hackett in 1840, and Hackett later subdivided to four grantees, all black."

It is believed that Marshalltown figured prominently in the Underground Railroad that assisted runaway black slaves who came across the Delaware River; it is also believed that a number of those fugitive slaves settled in or near Marshalltown. According to Sheridan, Marshall probably had been freed by one of several white families named Marshall living in Salem County.

## MOVERS AND SHAKERS

A number of African Americans living in Salem County played important roles in the life of Salem County, New Jersey and America before and after the Civil War. One of those people was Reuben Cuff. In 1816, he was one of the founders of the Philadelphia Conference of the African Methodist Episcopal Church. Sixteen years earlier, he, along with Chauncey Moore and Cuffie Miller, purchased land for the first AME church in New Jersey.

The Mount Pisgah African Methodist Episcopal Church on Yorke Street in Salem city was built in 1858. However, the AME congregation of Salem, first in New Jersey, was founded in 1800.

Worship services commenced in Salem city in 1802, but the current Mount Pisgah Church on Yorke Street was not built until 1878.

One of the most notable African Americans to grow up in Salem County was John S. Rock, who was first a teacher here and then went on to distinguish himself as a dentist, doctor and lawyer. He was the first African American permitted to argue cases before the United States Supreme Court. Still later in the nineteenth century, the Reverend Jeremiah H. Pierce of Salem argued before the New Jersey Supreme Court that segregated schools were unconstitutional.

John M. Dunn, grandson of an escaped slave, grew up in Mannington and later moved into Salem city. While a young man and artist, he painted a mural on the walls of Pauline's Bar off Market Street and later the portrait of Grammar School principal William C. Anderson. That painting now hangs in the library of the Salem County Historical Society. Dunn trained at the Industrial School of Art in Philadelphia. His painting *Emancipation Proclamation* and a marble bust called *Symbol of Faith* won him a bronze medal from the Pennsylvania Proclamation Commission in Philadelphia.

## FRIENDS SET AN EXAMPLE

While some African Americans escaping slavery in the South found their way to freedom in Marshalltown and remained there, many others were assisted to travel farther north by members of the Society of Friends, who

in Salem County not only were among the first white people to free their own black slaves but also were instrumental in passing antislavery legislation in the state. Those Salem County Friends, or Quakers, most involved in the Underground Railroad were Abigail and Elizabeth Goodwin, whose home on Market Street in Salem city was one of the first and most frequented stations on the secret system. William Still of Philadelphia, one of the prime movers in the Underground Railroad, said Abigail, who was more active in the movement than her sister, "was one of the rare, true friends to the Underground Railroad, whose labors entitle her name to be mentioned in terms of very high praise." Still quoted from a September 1862 letter sent by Abigail in which she commented upon President Lincoln's intention to issue the Emancipation Proclamation on January 1: "I have read the President's proclamation of emancipation with thankfulness and rejoicing, but, upon reflection, I did not feel quite satisfied with it; three months seems a long time to be in the power of their angry and cruel masters, who, no doubt, will wreak all their fury and vengeance upon them."

## Donald Pierce Remembers

*When I* [he is African American] *grew up in Salem city* [in the 1940s and '50s], *there were two elementary schools on the same lot. The one school faced Market Street and the other faced Grant Street. The school that faced Market Street was a predominantly white school for children in kindergarten through sixth grade, except that in the basement of that school was a room for black children in first grade. The room backed up to the school's furnace and had one toilet for the children and the teacher. The children had their own ground-level entrance. The school facing Grant Street was an all-black school containing grades second through eight. The high school was integrated.*

*In between the two elementary schools was one playground, and recess was separate for white students and black students. But the school day for both black and white students started at the same time and ended at the same time; we walked to school together, but we couldn't sit in class together. It never made sense.*

*When I was in* [the all-black] *school, there was a sense of belonging. The black teachers were interested in you, and they tried to make you feel that you were worth something. When I graduated from high school, I went*

# By Any Other Name it Spelled Freedom

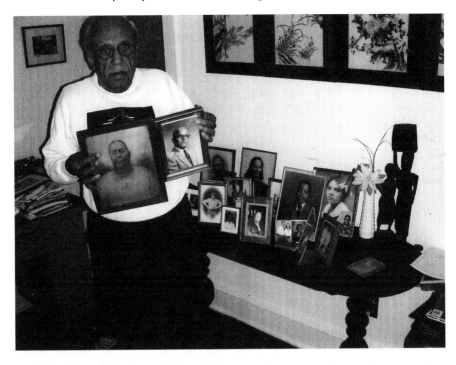

Donald Pierce is at home with his family's pictures. In his right hand is a picture of his grandmother, Rhoda Cuff, and in his left hand is a picture of his uncle, Kenneth Cuff. Pierce and those relatives are descendents of Reuben Cuff, son of a slave and a noted Methodist teacher in the late eighteenth and early nineteenth centuries.

*to all-black Lincoln University. After I graduated, I went into the army for two years. Then, I got a job as a teacher here in the high school. I was the school's first black teacher.*

New Jersey legislated integration in public institutions such as schools before the U.S. Supreme Court decision of the mid-1950s, Pierce recalls.

*I seem to think that there was a change in preparation the black students were experiencing under integration. They didn't seem to be as open or as confident as they were when I was in school. It seemed black students were better prepared when there was segregation. I don't know, but I think black students got sort of lost. At least that was my impression that year I taught in the high school. I don't think it's that way now.*

*As far as the community was concerned* [when Pierce was a teenager], *there were two movie houses where blacks had to go upstairs to the balcony. The Palace Theater on Broadway, which was segregated for*

*movies, was where the school district held high school graduation, and then the theater was integrated.*

The city was basically segregated, Pierce remembers, but everyone knew what they could and couldn't do. For example, the stores were integrated, but some restaurants were not.

*I remember coming home from school with friends one day and deciding we'd like to get some ice cream. There was an ice cream stand on Broadway at the time, but the man behind the counter wouldn't let us stay. He said, "A mammy raised me, but I can't allow you to sit here and have ice cream." So, I got angry and came home and raised cane and then went to see the president of the local NAACP, and he told me they couldn't do anything about the situation. Come to think of it, one of the boys with me at the ice cream stand was the son of the NAACP president. You know, I never joined the NAACP until a couple of years ago.*

Outside Salem city, many African Americans lived and worked on farms and, according to Pierce, in many of the rural communities children attended integrated schools. Of course, he said, African Americans owned some of the farms. "My mother's uncle, for example, owned farmland. In fact, when he passed, he left a farm to each of his three sons." The uncle was a descendent of Reuben Cuff, son of a slave in Salem County who was instrumental in founding the African Methodist Episcopal Church's general conference (see separate article on general history of African Americans in the county).

## *"Hooked on History"*

For three years, Pierce was chairperson of the Board of Trustees of the Salem County Historical Society and is still a board member.

*The funny thing is that I never cared for history growing up. In fact, some of the teachers I had in high school that I liked least were history teachers. I had a very good friend who was a history teacher at Lincoln University. All of us [majoring] in math and science used to call history and sociology and those kinds of courses bunkum. After graduating from college and after teaching, I started doing research into the Cuff and Pierce families, and I spent a lot of time at the historical society, and that's what got me hooked on history.*

Pierce believes that the reason he and many young people were turned off to history in school is because of the way it is sometimes taught.

> *For example, my world history class in high school* [consisted] *of going in and sitting down at the desk and outlining* [book] *chapters. It's too bad, because teachers can make history interesting. I took another history class* [in high school]—*United States history—and it was just remembering dates.* [The teacher] *didn't connect people to the dates. And naturally there was nothing* [in those days] *about African Americans. They just didn't exist as far as the U.S. history courses were concerned. I think we've come a long way since I was in school, but we still have a ways to go.*

## Long Ago in Woodstown

"Woodstown Borough is pleasantly located near the head waters of Salem Creek and has only recently been separated from Pilesgrove Township." So begins the early history of Woodstown as written by Cushing and Sheppard in 1883. "Around about it lies the richest agricultural section of Salem County." The town got its name courtesy of—or perhaps despite—the early settler Jackanias Wood, whose original home still stands on South Main

The Friends Meetinghouse on North Main Street in Woodstown is typical of the meetinghouses built by the Society of Friends throughout Salem County.

Street. According to tradition, British soldiers marching through town during the Revolution took a break and stacked their arms in front of the Friends Meetinghouse at the bend of the main road. According to the historians, Woodstown in the late 1800s was noted for its fairs conducted by the West Jersey Agricultural and Horticultural Association. During the fairs, the town was the scene of "much bustle, activity and animation."

## Becoming a Borough Wasn't Easy

Woodstown's separation from Pilesgrove did not come easily. The first attempt failed apparently because supporters of separation tried to circumvent existing law regarding such referenda.

Cushing and Sheppard explain:

> [The] *1878 petition was circulated and a private bill presented to the State Legislature to incorporate the village of Woodstown as a borough. This bill failed to pass on account of a decision of the* [State] *Supreme Court, pronounced that winter, to the effect that, under the amendments to the* [State] *Constitution, special legislation of that nature was unconstitutional. The bill was revised so as to be general in its features.*

That bill passed, but all that it accomplished was to authorize an election to be held. The election was held in September 1878, and voters decided against incorporation as a borough by a margin of 35 out of a total vote of 263. The historians do not explain why voters rejected incorporation at that time, but it may have had to do with the boundaries set for the borough. In any event, the question about incorporation was shelved for four years, until the Salem County Board of Freeholders established—or redrew—the boundaries of Woodstown. Finally, in 1882, the little town was declared official and became the hole in the Pilesgrove doughnut.

## The Philadelphia Connection

Present-day residents of Woodstown can stand on the corner of North Main Street and East Avenue (Route 40) and hail the bus heading into Philadelphia. Their ancestors in 1849 might have stood in front of the hotel up the street and waited to board the stagecoach for the city. Before that date, perhaps fifteen years earlier, the first stagecoach line was established by Joseph Cook, but it only ran between Woodstown and Penns Grove. The Woodstown resident bound for

Philadelphia took that stage to Penns Grove and there boarded a packet boat sailing up the Delaware River to Philadelphia, with a stop at Salem. Jackson Briant was the person who extended the line to Philadelphia in 1849. Of course, travelers—commuters—to the city had only two choices to make on the timetable: the stagecoach left in the morning and returned at night.

Cushing and Sheppard, writing in the second to last decade of the nineteenth century, were pleased to report that the railroad had or was about to replace the stagecoach. "The completion of the railroad from Swedesboro through Woodstown to Salem has placed Woodstown in direct railway connection with Philadelphia and points beyond, an advantage it should have had twenty years ago, and it will doubtless add much to the growth, prosperity and wealth of [Woodstown]." The historians did not explain what delayed plans for the railroad twenty years earlier, but modern-day citizens are well aware of how slowly the wheels of government can turn.

## Long Ago in Elmer

The town was named not for Elmer somebody but for somebody Elmer—the somebody being a prominent jurist and later a congressman with the very imposing and historic name of Lucius Quintus Cincinnatus Elmer. Since some earlier nicknames for the town, which once had been part of Pittsgrove, were Ticktown and Terrapin Town, residents were fortunate that the judge gave his name to the place. The borough was once divided by the West

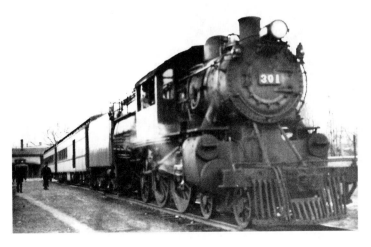

There was a time when steam engines moved people and goods in and out of the county. *Courtesy of* Today's Sunbeam.

*Above*: Elmer plans to restore this old railroad station and return it to where it first stood in the center of town.

*Below*: Thomas Haaf stands by his truck in Elmer. *Courtesy of the* Elmer Times.

# By Any Other Name it Spelled Freedom

*Above*: Old-timers in Elmer can't remember either the first name of Mr. Rogers or the name of his horse. *Courtesy of the* Elmer Times.

*Below*: The *Elmer Times* has been published in this building since 1885.

*Left*: Preston Foster III, *left*, is editor of the *Elmer Times* in Elmer. His brother, Mark, *right*, is the publisher. They are descended from Samuel Preston Foster, whose framed picture is over their heads. He started the newspaper.

*Below*: This is Mark Foster, publisher of the *Elmer Times*. The newspaper office and many of its furnishings and equipment go back to the nineteenth and early twentieth century.

Jersey Railroad, which connected Bridgeton and Woodbury. Cushing and Sheppard credit the railroad with attracting residents of some means and thriving businesses. They wrote in the 1880s that the village

> *is a growing one, the citizens being enterprising and having already formed a board of trade that offers, free of rents, desirable locations near the*

[railroad] *station to parties starting manufacturing purposes. The many trains north and south give the village considerable activity and provide facilities to reach the prominent points of the country with but little delay.*

The growing and enterprising started before Elmer became a borough in 1893. According to the *Elmer Times*, the petition that called for a vote to decide whether Elmer would become separate from Pittsgrove Township was drafted by George M. Bacon and S.P. Foster. They obtained the necessary signatures, and a vote was scheduled for January 4, 1893. The voting took place in Reed's Hall, and the petition was overwhelmingly approved.

## Busy, Busy

Cushing and Sheppard devote two and a half columns in their *History* to a long list of businesses that chose to settle Elmer's 0.9 square miles. Of course, not all the businesses listed were up and running at one time, but nevertheless, the borough boasted a considerable number of "parties starting manufacturing purposes" and a variety of retail stores.

Here is a sample of some of the businesses in town in the second to last decade of the nineteenth century:

This is the old grain mill in Elmer. *Courtesy of the* Elmer Times.

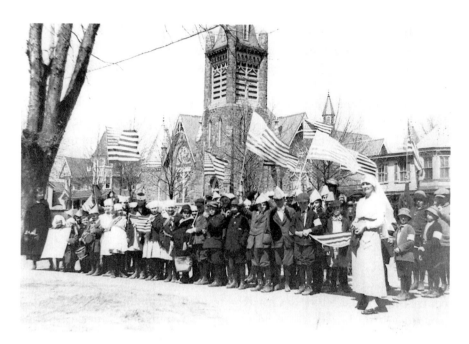

*Above*: Elmer schoolchildren are on a field trip. *Courtesy of the* Elmer Times.

*Below*: It's time for a good time in Elmer. *Courtesy of the* Elmer Times.

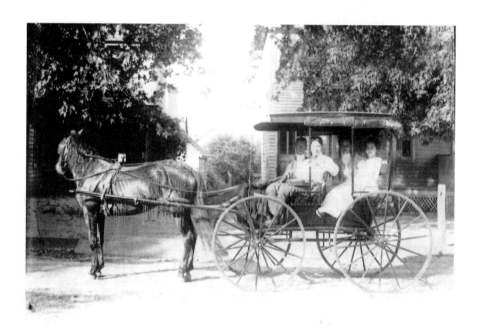

*William Johnson's and John Ackley's grist mills, John Ackley's steam saw mill, Joseph Gibson's marble-yard, Seth Loper's lumberyard, the spindle factory of Hitchner & Colling (in course of erection), the harness shop of William H. Kirby, Jonathan Brooks' and Frank Beckett's meat markets, the dairy of James B. Anthony, Charles Surran's livery stable, a barber shop, and lesser enterprises. There have been many successive wheelwrights, blacksmiths and shoemakers. The present representatives of these crafts are E.E. Long and Dennis Rodden, wheelwrights; David Beckett, William Long, and Thomas P. Rogers, blacksmiths; Casper Pfefer, William Coblentz and Thomas P. Wriggins, shoemakers. The resident professional men are Drs. Woodruff, Hitchner and Cheeseman and Abram Cochran, attorney.*

## No Staggering Allowed

A story passed down through the years claims that Main Street in Elmer was formed by men going to and fro between two taverns, one at either end of the town. Since Main Street is as straight as an arrow, one must assume, if the story is to believed, that the men who patronized the taverns drank modestly and were always in control and steady as they walked between the taverns. Otherwise, Elmer's Main Street might veer off here and there.

Another tale passed down through the years concerns Elmer as a magnet for local farmers who had tired of farming and turned over the day-to-day, very hard work to their sons—a nineteenth century retirement village, if you will.

CHAPTER 9

# "MEAN MUCH TO THE WORKING PEOPLE OF SALEM"

A front-page newspaper article on January 16, 1924, reported that John B. Campbell the day before had signed an agreement of sale with one Benjamin Carpenter to purchase from Mr. Carpenter 168 acres of farmland in Mannington Township, bordering historic Fenwick Creek. Mr. Campbell, reported the newspaper, intended to build a new plant on the property and that "the development of the Carpenter farm for factory purposes will mean much to the working people of Salem and will be quite as convenient as many sites within the city limits and yet allow for larger expansion, if necessary."

Larger expansion if necessary? Salem County didn't have long to wait for an answer.

A month before Campbell and Carpenter shook hands on the sale of Carpenter's farm, Campbell's felt-based floor covering plant on Hubbell Avenue in Salem city burned to the ground (see the Keith Campbell Remembers section later in this chapter about an earlier fire). Evidently, Carpenter was not suspicious or worried that he and his family were somehow jinxed. The J.B. Campbell Manufacturing Company was in business, and that's all that mattered. But what also mattered was that the company that had purchased a plant owned by the Campbells in Ohio insisted that the Campbell name could not also be used for the Salem plant. Consequently, Kenneth Campbell suggested at the next meeting of the board of directors that they call their plant Mannington Mills.

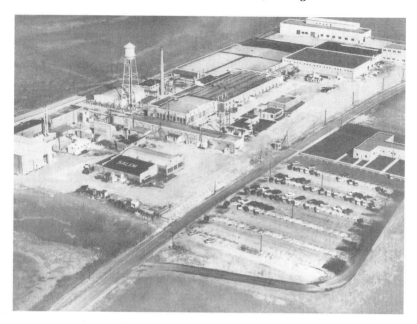

This is Mannington Mills seen from the air. *Courtesy of Mannington Mills.*

## No Mistake About It

Mannington Mills got through the Great Depression better than many companies, even though another fire burned the main building to the ground, and the company did have to print felt-based racing games for Lits and Snellenberg department stores in Philadelphia to help cover expenses and keep workers employed. New plants were built, and the company and the nation began emerging from hard times. For Mannington Mills, one morning in 1938 provided a giant leap out of hard times.

The company's eighty-fifth anniversary history book tells what happened:

*One morning in 1938, Kenneth Campbell had taken his children to school. This caused him to be late getting to the plant to approve a new pattern that the crew had already started to print. The paint foreman, Lawrence Riley, had made some changes in color. When Kenneth saw the result of Riley's color change, he said, "Lawrence, that looks terrible—what did the original look like?" Riley pointed to a sample on one side of the print machine and said, "It's right over there." Someone had put a plain piece of felt-based material on top of the sample. Kenneth told the men to pull the two pieces of felt-base apart so that he could check the color. After looking at the sample, he left the area. Later that morning, Neil Campbell saw that*

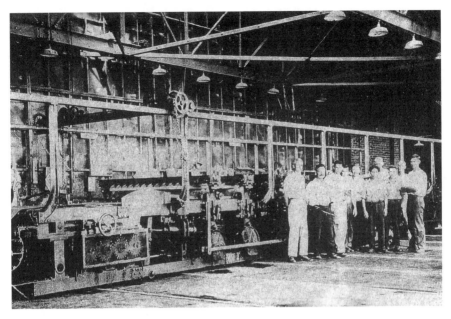

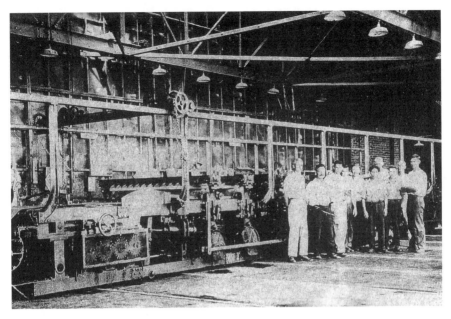

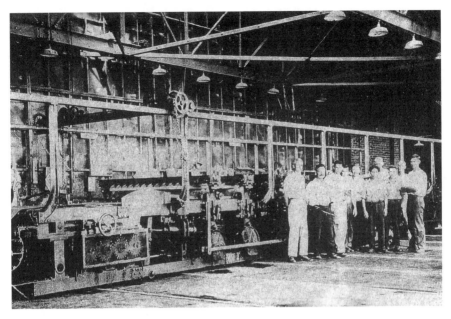

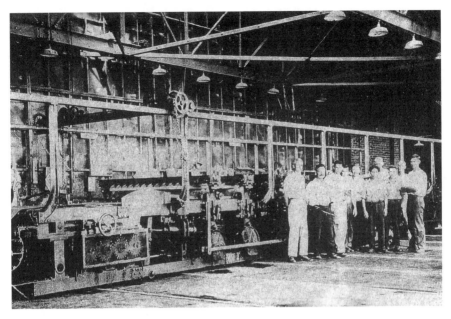

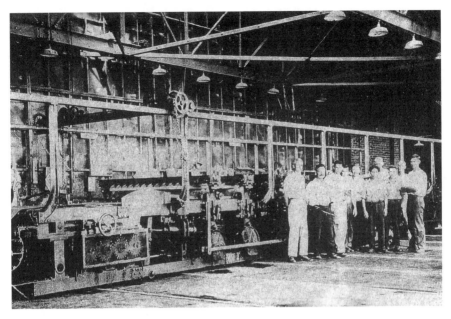

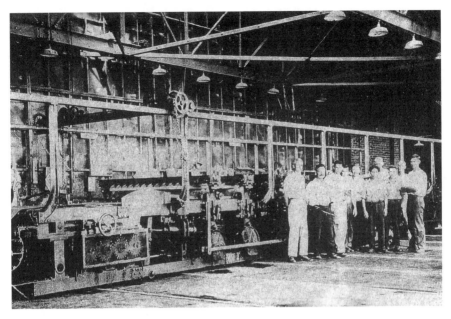

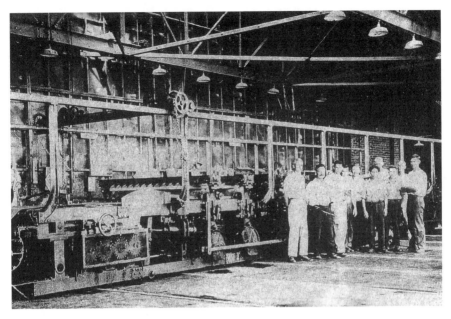

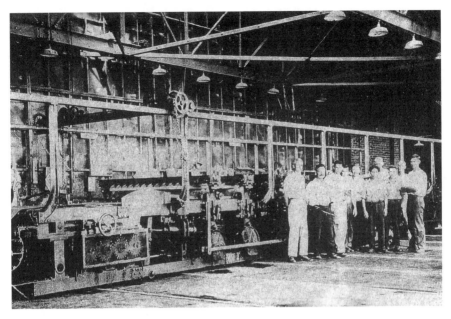

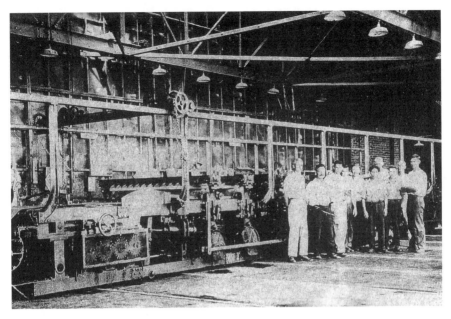

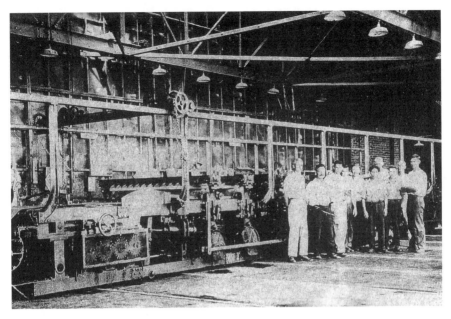

# "Mean Much to the Working People of Salem"

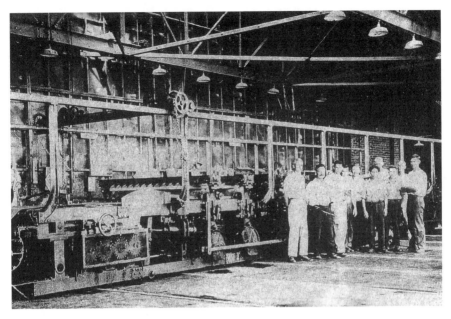

This flatbed print room opened in 1928. *Courtesy of Mannington Mills.*

*both pieces of felt-base had the same design on them, although only one had been printed. In that serendipitous moment, an idea was born that would provide employment for Mannington workers and financial stability for the company. It was the discovery of the transfer printing process or "kiss" method, as it was known to many in the floor covering industry. Neil received a patent for the process. The patent was good for eighteen years. Others attempted to duplicate the transfer method, but without success. Realizing the great potential of the process, the Campbells decided to liquidate all of their old inventory and to produce everything by the "kiss" method.*

With the accidental discovery of the transfer method, the Campbells also had discovered a new way to make a lot more money. Another serendipitous moment occurred thirteen years later. When the Paulsboro Manufacturing plant, a competitor, closed its plant in that town and decided to move west to Allentown, Pennsylvania, owner Jack Clement decided to have a kind of yard sale. Among those who went to the sale were Johnny Campbell and E.D. Huggard, Mannington Mills' plant manager. They spotted what looked like a drum supported by stanchions. Campbell asked what "that old thing" was. He was told that it was a four-station printer and had come from a linoleum plant in Staten Island, New York. Clement had never got it to

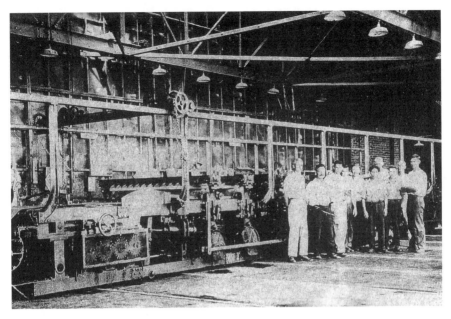

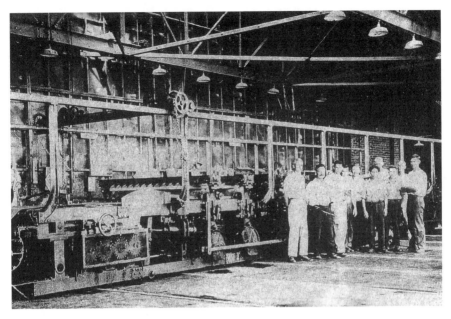

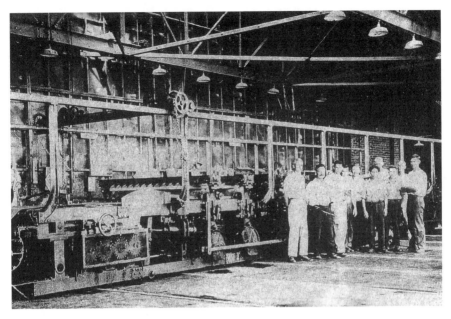

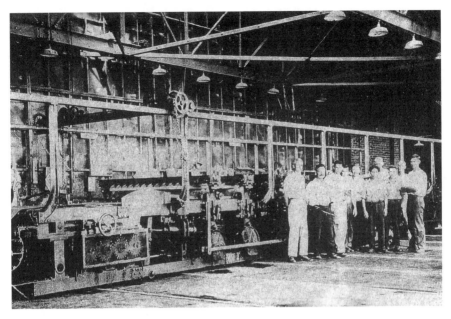

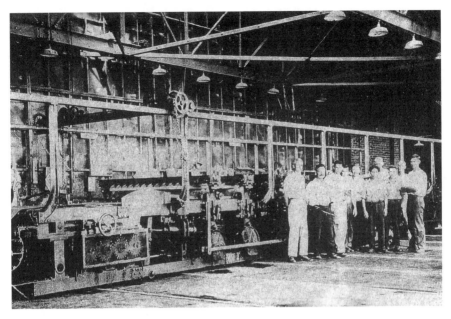

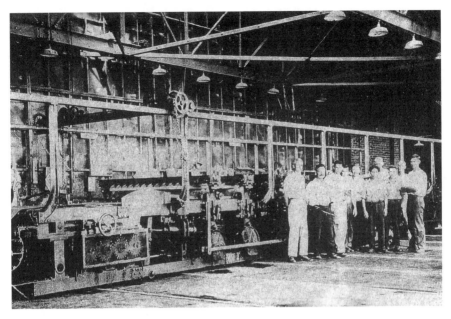

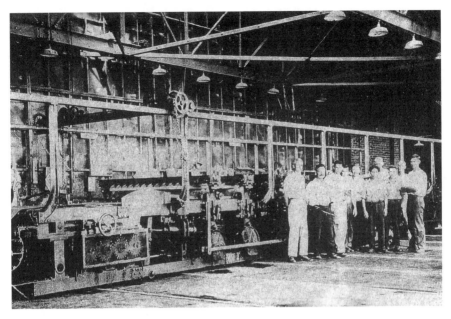

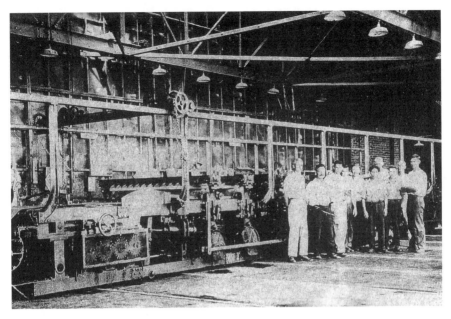

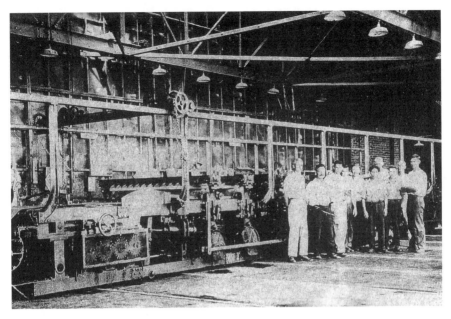

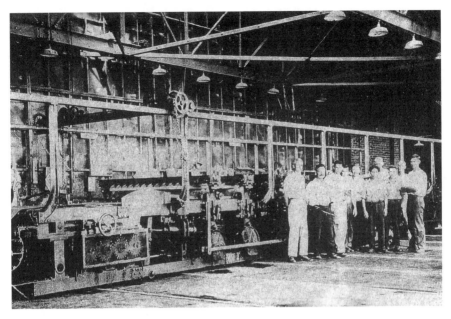

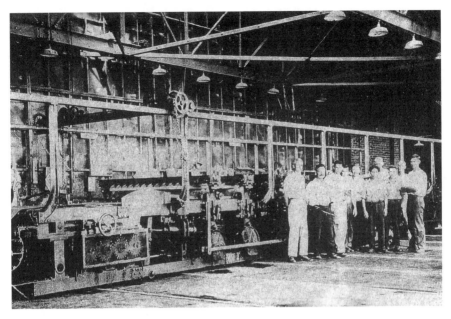

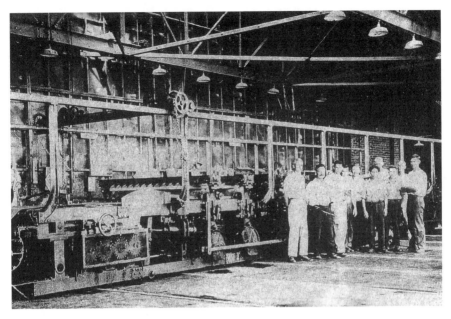

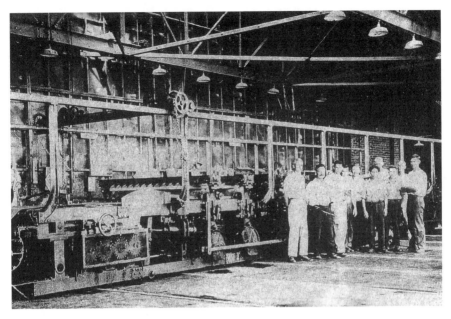

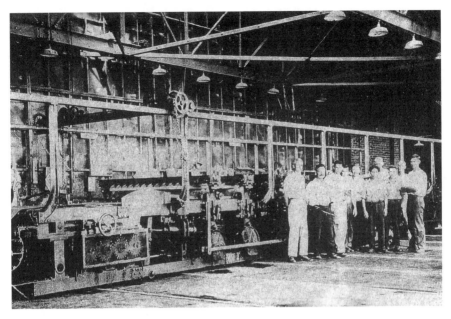

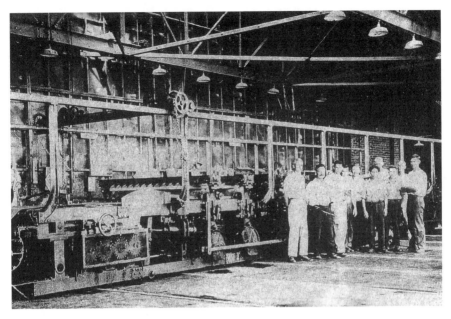

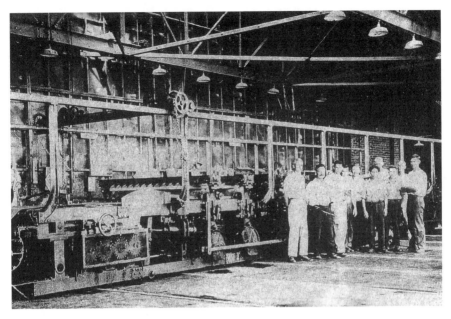

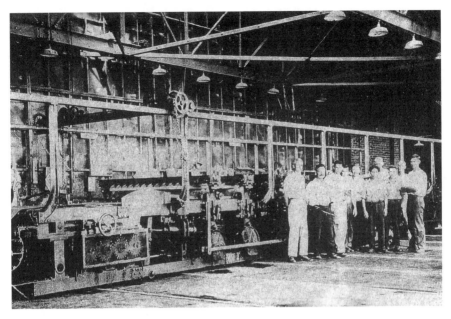

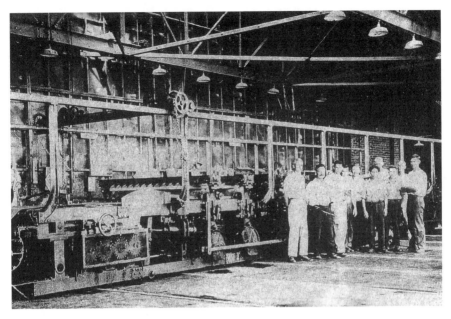

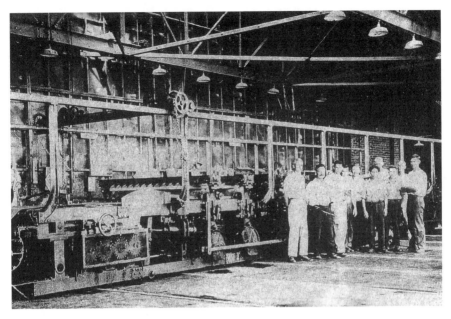

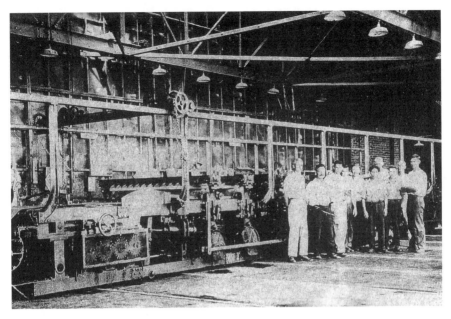

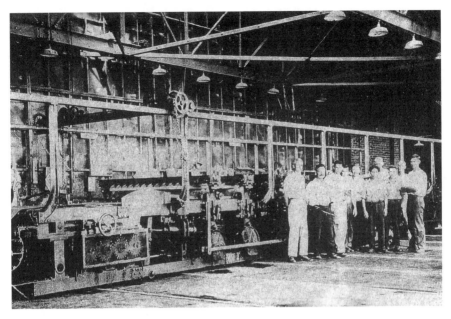

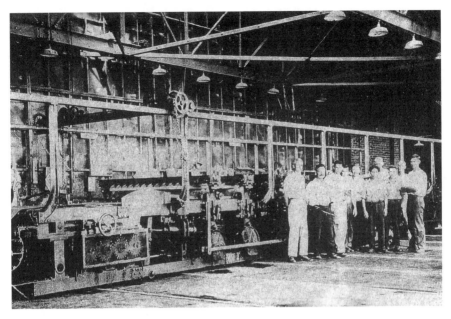

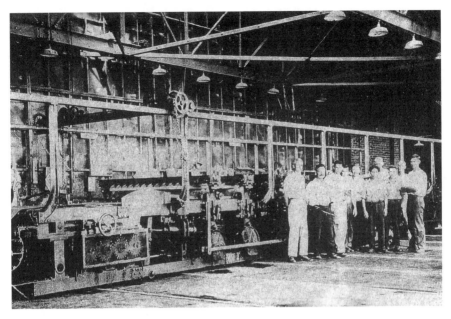

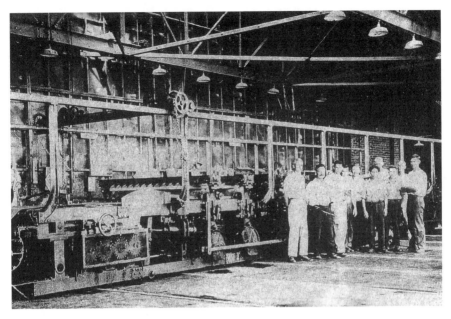

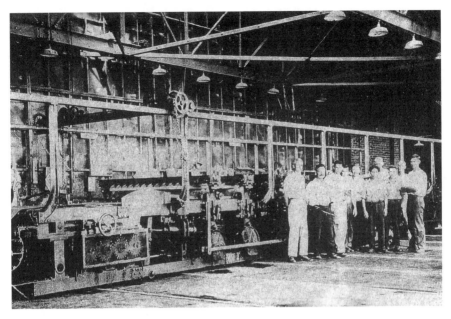

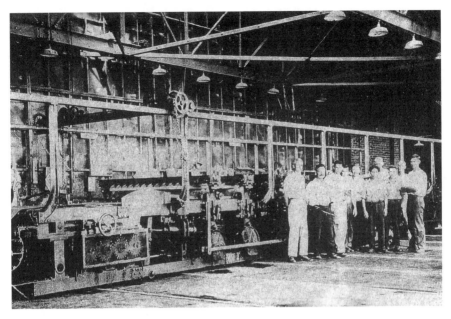

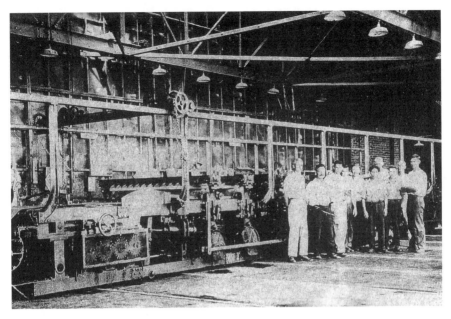

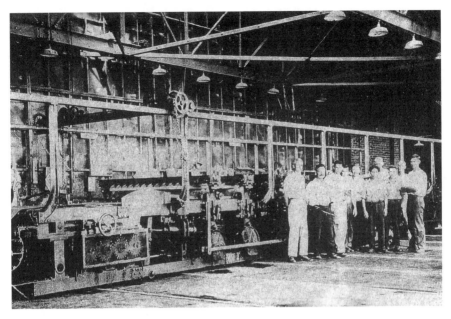

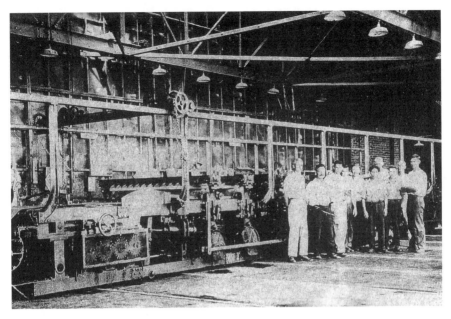

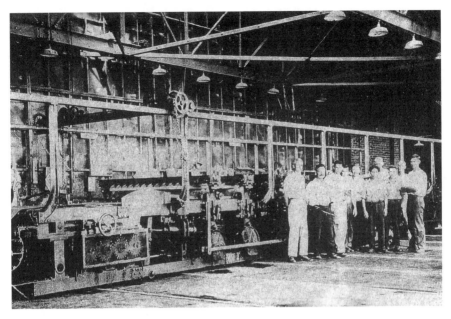

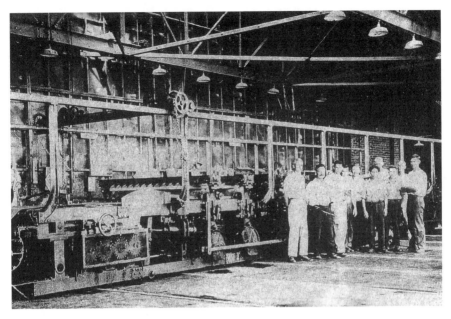

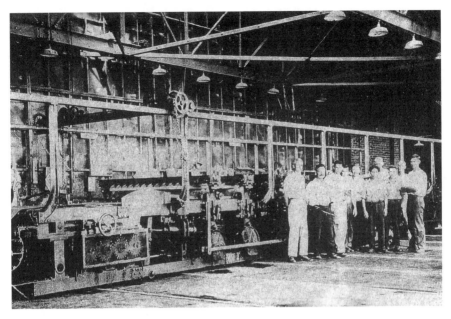

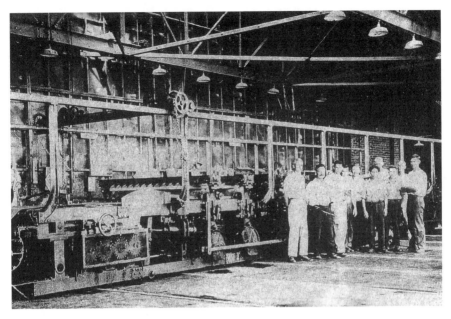

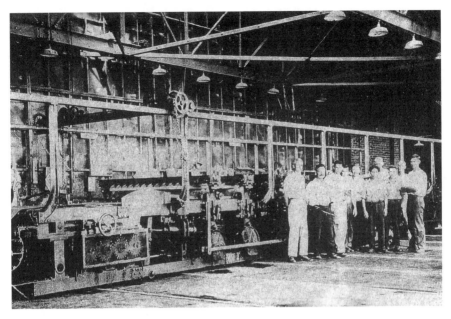

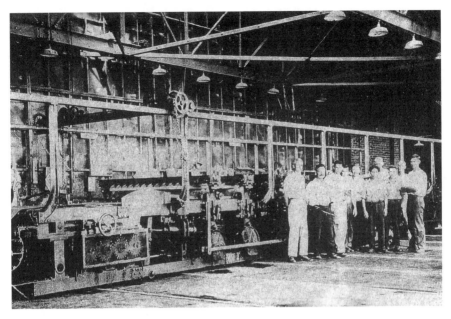

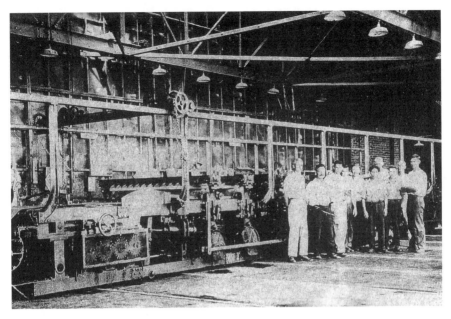

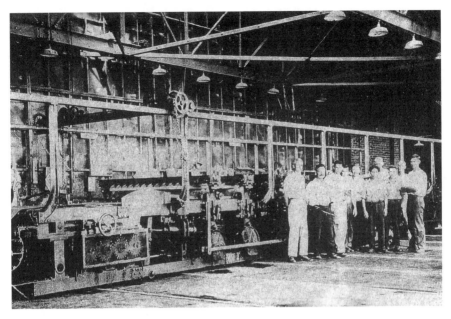

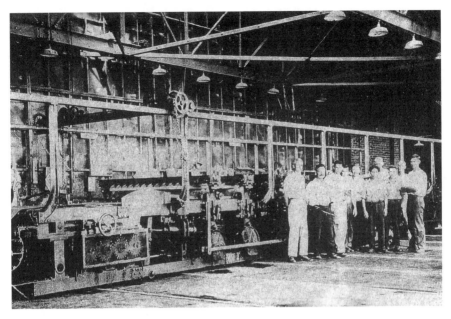

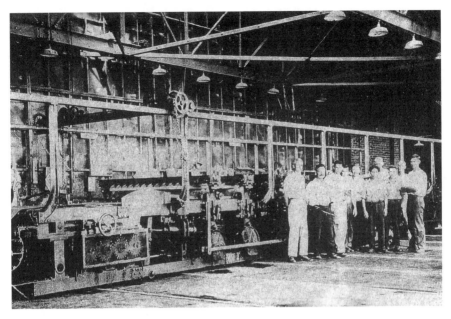

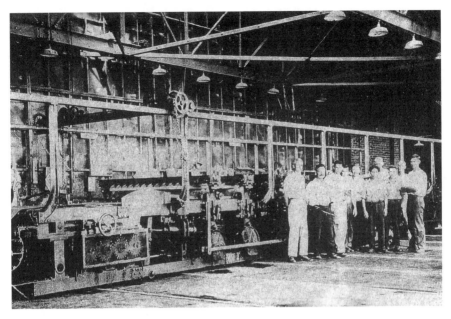

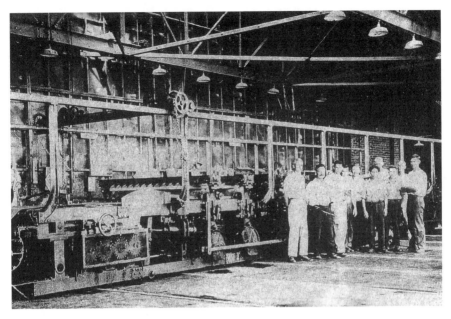

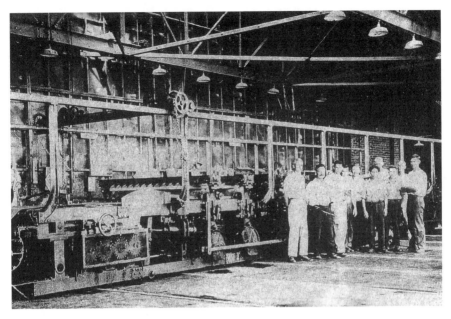

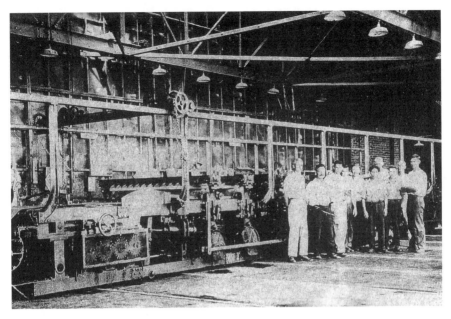

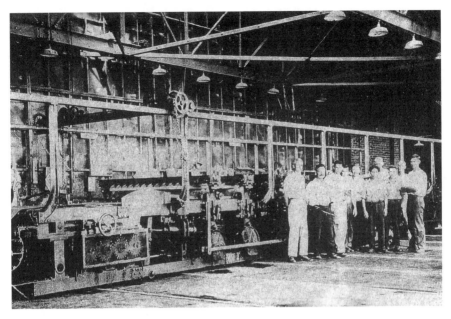

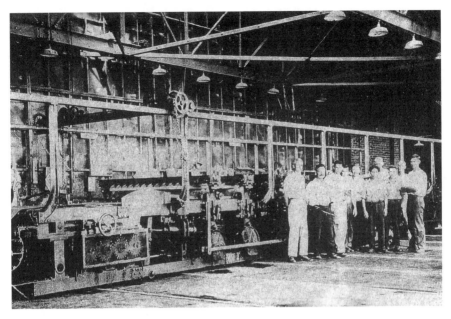

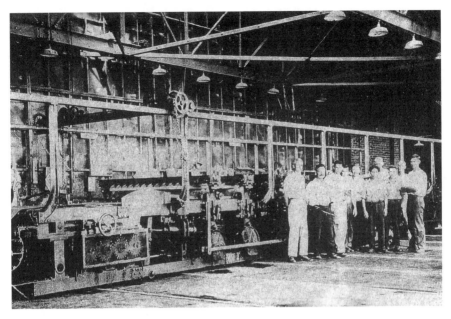

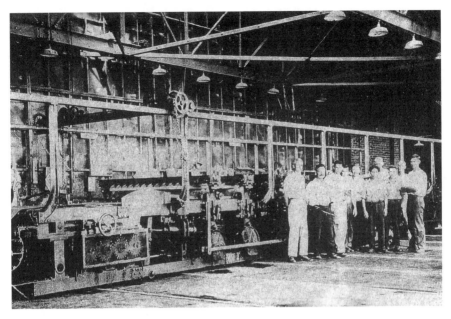

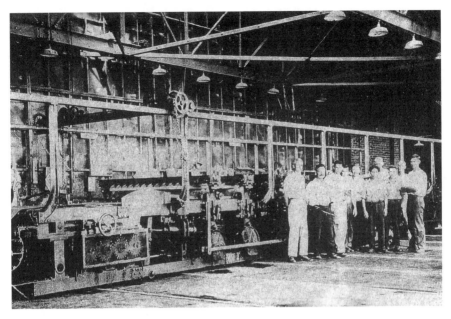

work, Campbell was told, and now Clement was going to sell it for scrap. Campbell suspected that the printer was not as worthless as Clement made it out to be, and he offered to "buy" it for a case of scotch whiskey (old J.B. Campbell, the Scotsman, would have been proud). The scotch whiskey was accepted, and the Campbells got the old printer.

Huggard and his men started working on "that old thing," and before long, it was producing wall covering. According to Mannington Mills' anniversary book, the company promoted the wall covering as the Mannington Mills Miracle Product of 1952. What came off "that old thing" was wall covering made to look like ceramic tile. The product was called Man-o-Tile. Two years later, a similar product, called Man-o-Top, was produced and sold as a kitchen countertop. "So many orders were received from companies such as Sears, Montgomery Ward and Spiegel that the printer was operated around the clock."

## Never Stop Growing

At a meeting of Mannington Mills stockholders in April 1970, management announced that not only had the company had "the best year ever," but— perhaps even more important—45 percent of all sales had come from products the company did not even offer four years ago. In the next decade,

This is part of the resilient manufacturing line at Mannington Mills. *Courtesy of Mannington Mills.*

126

# "Mean Much to the Working People of Salem"

The Campbell family has guided Mannington Mills for nearly a century. *Courtesy of Mannington Mills.*

the company not only expanded its product line but also expanded its advertising. For example, dancer Juliet Prowse and pitchman Ed McMahon were hired to promote Mannington Mills products. "Mannington's [national] recognition began to grow," the anniversary issue boasted.

Physical expansion followed:

> *The new office building, cafeteria, and warehouse were completed in 1978. The ribbon cutting for the new cafeteria was held on August 25. The new corporate headquarters was officially opened with an open house on October 15. The new warehouse was opened in November. In 1978. Mannington Mills owned 378 acres and had fifty-six buildings that occupied over twenty-five acres. There were over 800 employees on the site.*

As Mannington Mills celebrated eighty-five years in business and looked forward to the future, the anniversary issue closed by pointing to "challenges faced and challenges met: From customers alienated to customers delighted, from competitors scornful to competitors respectful, from product failure to product success, from major management weaknesses to outstanding management strengths, from a future full of doubt to a future full of promise."

# Keith Campbell Remembers

Keith Campbell earned a degree in business and history from Muskingum College in Ohio. Talk about the right preparation for life! Even as a college freshman and the last son of a distinguished Salem County and world-renowned family, he knew—or was almost positively certain—that one day he would be in overall control of the family's business, Mannington Mills. Today Keith Campbell is chairman of the board of the company. Incidentally, he credits Kenneth Campbell, his grandfather, with the company name. "He called the company Mannington Mills instead of Mannington Mill because, by adding the 's,' the company sounded bigger than it was." Remembering how college prepared him for life in general and particularly for a life in the world of business—any and all business pursuits, Campbell has been especially active in helping to guide the destiny of Rowan University and its students and potential leaders in business and potential history makers. He has served as chairman of the university's board of directors, and the university's library on the main campus in Glassboro bears the Campbell name. When one talks with Campbell about the family and Mannington Mills, one receives a history lesson but not the kind you might get from a book or from a classroom teacher. Well, read on; you'll see.

Keith Campbell, chairman of the board of Mannington Mills, stands in front of framed flatbed linoleum printing blocks.

## In the Beginning

"When people think of Mannington Mills today, they think of vinyl floor covering," said Campbell,

> and that [concept] is an historic link to 1915, although at that time it was not vinyl floor covering; it was what was called felt-based linoleum. My

*great-grandfather, John B. Campbell, worked for a linoleum manufacturer in Scotland, and when he emigrated from Scotland to the United States, there were oil cloth manufacturers in addition to those making what was then called poor-man's linoleum. When my grandfather arrived in this country, he went to work converting some of these oil cloth companies into making felt-based linoleum.*

The year was 1910. Three years later, his great-grandfather came to Salem.

"Now, some of what I am about to tell you is folklore and some isn't," Campbell warned. Then he told this story:

*There were these two guys who owned the old American Oil Cloth Company* [at the end of West Broadway in Salem]. *One was a retailer and one was a judge. My great-grandfather came down here* [to Salem] *to convert this oil cloth company into making floor covering. As he was doing it, the retailer, who confessed the company wasn't making much money, asked him—and this is true—to burn down the company. My great-grandfather then went to the judge and told him that his partner was not a very reputable guy. The Pinkerton cops arrested the retailer. Then there was a sensational trial, and my great-grandfather was the star witness. The retailer was found guilty, and my great-grandfather went back up to north Jersey and said, "I've had enough; I've done my gig." A year or so later, the* [same] *judge got in touch with my great- grandfather and said, "I'd like you to come down and run* [the company]." *My great-grandfather said he wasn't in to running anything. Then the judge said, "What I'd really like is for you to own the company." My great-grandfather, who was a poor Scotsman who had married well, said he didn't have the money. So, the judge signed the note at the bank in Salem, and my great-grandfather took over the American Oil Cloth Company. He proceeded to get it into tip-top shape, and then he turned around and sold it to Congoleum Nairn, a company that had a loose connection to a company in Scotland. He paid off the note* [signed by the judge] *and built another plant. That plant burned to the ground in about 1924* [no arson involved]. *He built another plant in our present location.*

The rest is history, as the saying goes, and much more of that early history is recounted earlier.

## ...And Today

Now, ninety-six years after John B. Campbell came to America from Scotland, his great-grandson can say that Mannington Mills is the only manufacturer in all of North America that handles all surfaces (floor coverings). "If you look at Mannington today," said Campbell, "we're still Salem, I'm still Salem and we still have our plant here, but we have seven manufacturing plants, two twin ventures we're in, and two thousand employees here and elsewhere. Armstrong is bigger than we are, but you don't have to be the biggest to be the best."

Looking ahead, Campbell pointed out that Mannington Mills recently purchased a rubber flooring company that has manufacturing plants in Florida and California. "We made those purchases in the middle of a recession, so that was big!" Among other things, the acquisitions will enable Mannington Mills to produce rubber stair treads.

> *Right now, our emphasis is on streamlining things. We just had the worst recession since the Great Depression, and our residential business has been very much affected by that, so we've had to make a lot of adjustments. Our commercial business is growing, and today we find ourselves a larger commercial company than a residential company. That's a first ever for us.*

The company will continue to meet the demands of changing times, Campbell said, but "we can't wander too far off the reservation as it were. We know flooring and we know it well."

# DuPont Ignites Boom Times

The deed dated July 19, 1891, transferred 198.85 acres of the old Thomas Carney farm that fronted on the Delaware River below Helms Cove in Upper Penn's Neck Township (now Penns Grove) to five brothers trading as E.I. duPont de Nemours & Company of Delaware. Ten years later, the brothers duPont bought another 66.61 acres. Historian Bill Lynch wrote that the reason the brothers gave for purchasing the land in Salem County was "the need for a remote location." It is not certain whether the duPont brothers explained to local farmers and storeowners why they needed a "remote location," but it definitely had to do with what had been happening across the river and upriver in Gloucester County.

Local residents certainly should have remembered what occurred on a Saturday morning in March 1884 at Repauno:

> [Lammont duPont] *was in the laboratory when a workman rushed in to tell him that 2,000 pounds of nitroglycerine that was supposed to be cooling in a lead-lined tank nearby was beginning to fume. Lammont hurried to the scene to empty the mixture into a water tank but realized he was too late. He raced out of the building with four other men, all making the most of the few seconds before the explosion. Lammont's lanky frame lunged through the air for the safety of an earthen mound just as the impact of the exploding nitro smashed into him. All five men were killed instantly.*

While the company's need for a "remote location" did have to do with the company's interest in and manufacture of explosives, the nature of the explosives had changed. Whereas Lammont had been working with nitroglycerine, the company's plant in Salem County planned on manufacturing what it called smokeless gunpowder.

The mammoth DuPont history published in 2002 reported that by the decade after what happened at Repauno,

> it had become commonly known that when cotton or some other cellulose material was soaked in nitric acid, it became highly explosive but left no smoke trail to obscure vision or give away a location. In 1893, Frank [duPont] patented a smokeless gunpowder for ordinary shotgun use. Eight years later [1901] DuPont opened a smokeless powder plant for military artillery at Carney's Point.

## Population Explosion

DuPont may have switched from nitroglycerine to smokeless powder, but explosions did not end and neither did the killing. Five men were killed in 1899 while testing the powder in a press mill, and the *New York Times* reported on May 25, 1915, that "one of the operating mills at the plant of the DuPont Powder Company at Carney's Point, NJ was wrecked by an explosion at 4:30 o'clock this morning. It was the fourth explosion at the plant within ten days. Five men were burned."

While the booms from smokeless powder explosions rolled across the farms of Salem County and rippled across the river to DuPont headquarters in Delaware, the population in and around Carney's Point exploded. The cause of the explosion was World War I and the need for gunpowder.

Historian Joseph S. Sickler wrote about it:

> Responding to this demand, [the DuPont Company] set to work to build two more units of their smokeless powder plant at Carney's Point. In less than a year this huge manufacturing concern had extended from a tip of land on Carney's Point several miles southward to the canal at Deep Water point…The demand for carpenters, masons and workmen generally far exceeded the supply. Farmers of Salem County dropped their plows in the field to become carpenters, mechanics and operators at fabulous wages.

*The skilled labor of this county and of neighboring Wilmington was drained to the last drop. From all parts of the United States, knowing that a job awaited them in far distant Penns Grove, came skilled workmen and laborers in droves. The little borough of Penns Grove, whose population in 1910 was less than 2,000, jumped to 10,000.*

## BUILDING THE RUBEROID VILLAGE

Of course, ten thousand people—mostly men—needed somewhere to stay, and naturally, Salem County wasn't prepared for that influx. The first attempt to meet the demand was a series of bunkhouses that could accommodate up to five thousand men. The cluster of bunkhouses was called, simply, the Camp. The bunkhouses were followed by the Ruberoid Village. The material Ruberoid was used to help seal outside walls in the village of small houses. By late spring of 1915, DuPont was expecting as many as five hundred carpenters to arrive from New York and from as far south as Baltimore to build the Ruberoid Village, which was first located between Shell Road and the river and mostly north of Walker Avenue. The houses were arranged so that the back door of each house faced the back door of another neighboring house. Each house had to heat and cook with coal. The first 150 or so houses built contained six rooms, including one bathroom and kitchen.

The Ruberoid Village spread, with some of the later houses being two-story; as many as 250 of these houses were constructed on the east side of Shell Road. Each rented for eight dollars a month. Some people then and perhaps now have referred to these houses as apartment complexes, or worse, barracks, because six were attached in a row as one might find in the city. According to the publication *The Way It Used to Be*, "Each house had a kitchen, a dining room and a large living room on the first floor and a bathroom and three bedrooms on the second floor. Each house had a large front and back porch attached to that of the next house. Each house had a large coal bin…near the back porch."

In the summer of 1917, the company hired one hundred women and built six two-story dormitories for them. Each floor contained twenty-four rooms, and each room accommodated two women. Each dormitory had equipment for washing and drying clothes. For the convenience of the women, DuPont and the local YWCA built and operated a nonprofit restaurant.

## To Dye For

The World War I years were good to DuPont. At the end of the war and for the year 1918, the company posted accumulated earnings of $68 million, which was more than seven times the earnings for 1915. However, with the war coming to an end, the demand for smokeless powder decreased markedly. So it was that later that year the company decided to "spread beyond explosives into fields like dyestuffs, plastics and paints."

In the spring of 1917, the company built the Jackson Laboratory at its Deepwater plant (the name Chambers Works was not used until more than twenty years later). One of the first assignments for the chemists working there was to come up with a new line of dyes. "Despite their new facilities," stated the DuPont 200th anniversary book, "researchers soon became frustrated by unanticipated problems in producing particular hues consistently, then in scaling up production to turn out bulk quantities."

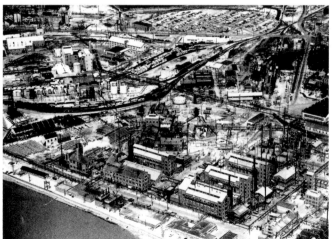

*Above*: This is a scene from the early days of DuPont in Salem County. *Courtesy of DuPont Chambers Works.*

*Left*: The Chambers Works site goes back to 1917. In 2004, DuPont celebrated its eighty-fourth year in Salem County. *Courtesy of DuPont Chambers Works.*

# DuPont Ignites Boom Times

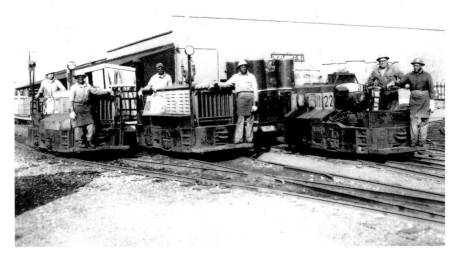

DuPont workers are ready to roll. *Courtesy of DuPont Chambers Works.*

Researchers—and the DuPont Company—became a lot more frustrated when the nation and the world slid into the Great Depression. "Nationally, dye production fell by 45 percent from 1920 to 1921," reported the anniversary book. "Employment in the Deepwater dye works dropped from 3,500 early in 1920 to 900 by 1921. The staff of 565 at Jackson Lab was cut to 217 in just a few months."

The production of dyes bounced back as the nation and the company emerged from the great economic crisis. By 1928, the Dyestuffs Department reported a modest profit. However, an even greater profit accrued from the dye research. "The experience and expertise the company acquired in its protracted dye venture," reported the anniversary book, "benefitted many other projects and product lines, adding value in ways that could not always be traced with an accountant's pen." The sentence that followed perhaps says even more about DuPont and its centuries of success and its impact on the way the world lives: "DuPont thrived not only because its products were so diverse but, more fundamentally, because their underlying chemistry was so similar." In other words, the research that went on in the Jackson Lab almost always had application in the development of many different product lines.

The manufacture of dyes was phased out at Chambers Works in 1978.

## What about the Future of Plastic?

The Chambers Works newspaper *Carney's Pointer* carried an article in its June 1941 issue that bore the headline "Plastics in Defense." The lead paragraph quoted L.B. Gillis of DuPont's Plastics Department as saying that, while plastics (which, of course, DuPont research had made possible) was to play a major role in the nation's defense program, "the public should understand that there are limits to which plastics may go in replacing metals and other scarce materials."

Uh-huh.

## Chambers Works Today

The site along the Delaware River has increased substantially from those 200 acres the duPont brothers purchased in 1891. Today, the company's plants are scattered over 1,400 acres, although 150 of those acres have been set aside as a wildlife habitat (where eagles roost). While the media may no longer tout such major discoveries as new dyes, Teflon (credited to chemist

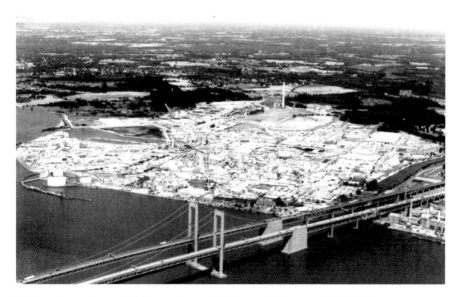

DuPont is spread over 1,500 acres along the Delaware River north of the Delaware Memorial Bridge. *Courtesy of DuPont Chambers Works.*

Roy J. Plunkett, at right, accidentally invented Teflon in 1938. *Courtesy of DuPont Chambers Works.*

Roy Plunkett), nylon, neoprene and Freon, the world's population still benefits from what is produced by 670 employees and 300 on-site contractors. Today the Chambers Works plants produce more than four hundred chemicals that support many more products and markets.

In 1949, the publication *This is DuPont* stated, "DuPont research begins with a study of basic scientific problems and proceeds from there to the creation of new chemical products and the improvement of existing ones. Research never stops." Indeed.

# Long Ago in Carney's Point

In 1675, wheeler-dealer John Fenwick talked the Lenape Indians into selling a goodly chunk of land bordering the Delaware River, which they didn't own, for a little rum and a few knives and scissors. Much later, the land, all 17.8 square miles of it, became known as Upper Penn's Neck. Still later, during the general election in November 1976, Fenwick's steal became Carney's Point. The current name can be traced to an Irish immigrant by the name of Thomas Carney. He and William Summerill purchased about 200 acres

around Helm's Cove and established their estates. Carney's granddaughter, Hannah, married Robert G. Johnson, the historian, and their offspring eventually sold the land to the duPont family in 1891. As they say, the rest is history, and that DuPont history is reported earlier in this book.

In 1770, when Carney's Point was still known as Upper Penn's Neck and Pennsville to the south was known as Lower Penn's Neck, people unknown proposed building a canal bordering the two townships that would allow flatboats to transport lumber and various wood products from the interior to a dock on the Delaware River. For whatever reason, the proposal failed to gain support. However, people in both townships—presumably businessmen and perhaps government officials—again proposed building the canal in 1800. For reasons not fully known, the plan was laid aside. Thirty-eight years later, men were employed to dig a canal, but their effort produced a ditch that would not accommodate boats large enough to carry a good-sized cargo, making ships wait in the river.

Finally, in 1868, wise men in both townships got the state legislature to pass an act that authorized taxing properties along Salem Creek to finance digging a proper canal. Men from both townships were elected as managers to oversee the project. They were Elisha Bassett, David Pettit and John Bassett of Mannington (where the canal might originate); William Summerill, George Biddle and Robert Walker of Upper Penn's Neck; and Robert Seagraves of Lower Penn's Neck. The canal was to be twenty-four feet wide through upland and forty-eight feet wide in the meadow. The water in the canal was to be five feet deep. By 1872, the American Dredging Company of Philadelphia had completed one cut the full length of the proposed canal, approximately two miles. The total cost of digging the canal was $35,000.

According to the official history of Upper Penn's Neck,

> the canal was a success for farmers east of the canal. Boats started to haul farm products starting at Courses Landing bridge now on the Auburn-Salem Road. There was a wharf there on both sides of the bridge. Thousands of baskets of farm products were shipped from there and other wharves east of the canal. The last [wharf] before reaching the river was Biddles Landing at what is now Cedar Rest. Tomatoes came into their own, and in the 1890s and early 1900s hundreds of thousands of baskets were hauled to canneries as far south as Baltimore.

Boats stopped using the canal in about 1920 when trucks traveling over better roads were able to move goods much faster than boats on the

canal. An act of the state legislature in 1933 officially closed the canal to navigation. Later, a dam was constructed to create a fresh water reservoir used by DuPont's Chambers Works. According to the official history, the economic value of the canal today is far greater than it ever was, so our forefathers built better than they ever dreamed.

## Long Ago in Penn's Grove

Once part of the now defunct Upper Penn's Neck Township, Penn's Grove became a separate township in March 1894 and also became the smallest township in Salem County at slightly less than one square mile.

Upper Penn's Neck had been formed in the middle of the eighteenth century, and for most of the next one hundred years, the area known as Penn's Grove contained only one house. The population grew rapidly in the nineteenth century to support three major industries in the township. In order, they were fishing, canning and hostelry. Those people working in these industries were supported by several general stores, a butcher and a bakery, but they also found relief from their hard work at four saloons, two pool rooms and one tobacco store.

Steamboats brought both goods and people from Philadelphia to the shores of Salem County. *Courtesy of* Today's Sunbeam.

Oh, for the days when families did not have to worry about rising gasoline prices.

The fishing industry included those men who went out in boats to harvest primarily shad, herring and sturgeon. Gill fishing off Helm's Cove was extensive. So-called gill nets were let down vertically into the water so that fish swam into the nets and became entangled. According to Cushing and Sheppard, writing in the 1880s, eighteen nets were employed and the cost of each net was $250. "They [the fishermen] earn from three hundred dollars to one thousand dollars each year, and each net furnishes employment [for] two, sometimes three, men." Many more people were employed in processing factories that cleaned and prepared the fish for shipment to Philadelphia and New York markets.

In the last two decades of the nineteenth century, Penn's Grove was surrounded by farms growing tomatoes, and according to historians, few towns were better suited and prepared to can those tomatoes than Penn's Grove. A small cannery operated by Peterson & Tussey began the industry in 1879 with the brand name Standard. In that first year, the cannery packed 5,000 cans of tomatoes. The next year, the Summerill brothers took over the business, and employing PR pizzazz before PR pizzazz was invented, changed the brand name to Jersey's Favorite. It worked! The firm increased the pack to 60,000 cans. The next year the cannery was expanded, a new boiler was installed and better canning machinery was installed. That year,

the company packed 160,000 cans of tomatoes. According to Cushing and Sheppard, by 1882 the business ranked as "one of the most complete canning establishments in the state. This firm packs nothing but cold, hand-packed tomatoes and warrants every can for one year after being packed, so that their trademark is a sufficient guarantee to the consumer that he is receiving the best in the market."

During the canning season, the industry employed seventy-five to one hundred people.

At about the same time that the canning industry began to flourish, Penn's Neck entrepreneurs realized that the township's location on the Delaware River—not too far downstream from Philadelphia but far enough from the city environment—could entice city dwellers to leave that environment and sail to quieter and healthier Penn's Neck. The main attractions were French's Hotel, which offered luxurious accommodations, and French's Grove, which offered a path along the river bank lined with shade trees. Could anything be better than comfortable accommodations, excellent food and cool, quiet summer breezes? Many affluent city dwellers answered no, and the hotel prospered.

## The Case of the Wayward Elephant

It was a pleasant fall evening in 1837 when a small circus comprised mostly of animals crossed over the Delaware River from Wilmington aboard a steamboat. On board was an elephant, the star of the production. Upon the boat's landing, the show's handlers led the elephant away from the dock and instructed it in some manner known only to showmen to stand in place until the entire menagerie could be offloaded. The elephant had another plan.

Cushing and Sheppard describe what happened:

> On this occasion, the elephant, instead of waiting, started on and took the upriver road...to the Pedricktown Road, thence making his way up that road a short distance to...the farm of Rinear Latchem. This led into the woods and swamps known as Quillytown, a wild region of country with few inhabitants. The elephant stayed in the woods that night and the next day. The following night he came back by the way he had gone the night before...When he arrived at Penn's Grove, not having had his regular meals, it is supposed he had a good appetite. Noah Humphreys, the hotel keeper, had a small building for the storage

*of feed. The elephant knocked in one side of this building and ate what oats he wanted, then went along the shore above the pier, where lay a small* [boat] *above high water mark. Whether the anchor was in the boat or not is not known, but the elephant took the boat from the shore and halfway across the river, where it was found anchored the next morning. The elephant, having left* [the boat], *he struck out alone for the Delaware shore and landed at Quarryville about sunrise.* [The quarry workmen] *claimed him as a prize* [but received nothing]. *The elephant was brought* [back] *over* [the river] *and taken to Woodstown, where the show was on exhibition that day.*

Have questions? Sorry, Cushing and Sheppard have no answers.

# Long Ago in Pennsville

At first, Lenape Indian families lived in small villages on the east shore of the great river; then a few hearty souls from as far away as Sweden and Finland came and settled the land; after them came English families led by John Fenwick. A century later, the place was called Lower Penn's Neck to honor William Penn. Now two more centuries have passed, and the land is called Pennsville Township. It is, at nearly twenty-five square miles, the largest municipality in Salem County.

Thomas Shourds, in his 1876 *History and Genealogy of Fenwick's Colony*, cites Anders Cenca Jr., a Swede, as probably being the first white man to settle on the eastern shore where the river bends. The name was later spelled Seneca. According to Shourds, "Anders Seneca, Jr. bought a large tract of land at Obisquahasit, now known as Penn's Neck, of the natives and settled thereon, that being about thirty years prior to Fenwick's arrival with his English colony." The name Seneca was later corrupted to Sinaker and Sinnick and finally to Sinnickson, according to Shourds. Thomas Sinnickson commanded a company in the Continental army during the American Revolution. After the war, he headed the Federal Party in that part of New Jersey that included Salem County; he later became a state legislator and then a member of Congress from 1796 to 1798.

The American Revolution lasted less than ten years; it took sixty-two years to settle the Fishermen's War that pitted fishermen from Pennsville and vicinity against fishermen sailing out of Delaware ports. The battle was over boundaries. Fishermen from both states prospered according to the number of shad and sturgeon they were able to net. The problem was that both sides claimed to know

the boundary dividing New Jersey fish and fishermen from Delaware fish and fishermen, but in truth, neither side was really sure where the boundary was or whether it even existed. The ongoing dispute got really nasty in 1872 when name calling, finger pointing and even net slashing reached the point where many fishermen from both states started to carry weapons with them on their boats.

Finally, one day in that year, the Delaware fishermen persuaded state or federal authorities to arrest twenty Pennsville fishermen on a charge that they were fishing on the Delaware side of the river.

Each man was fined twenty-five dollars, not a small sum in that day. It is not entirely clear whether the fishermen paid the fine, but they did appeal to New Jersey governor Joel Parker for relief. Like a good politician, Parker urged all sides to stay calm and to respect each other's territory (which was what the quarrel was all about) while he and others appealed to the United State Supreme Court for settlement of the dispute.

An uneasy truce followed. Fishermen from both states agreed, sort of, that the boundary between the states, pending the court's ruling, would be an invisible line down the middle of the river. Invisible lines are hard to see, so it was not uncommon for Pennsville fishermen to claim that Delaware fishermen had crossed the line and vice versa. In any case, the fishermen who claimed the other side had crossed the line would likely cut that state's net lines.

The Supreme Court, whose long-delayed decision was attributed to an exhaustive search of historical records presumably going back to the seventeenth century, ruled that the river boundary dividing the interests of the two states was "to reach the low water mark on the New Jersey side of the river for the distance of a twelve-mile circle beginning at the Court House in New Castle, Delaware [across the river from Pennsville]. Beyond the twelve-mile mark the boundaries extended to the middle of the river."

Were New Jersey fishermen happy? The historical record does not answer the question, but one might presume that fishermen's tavern talk in and around Pennsville might have been heated on occasion. Oh yes, the record also does not show if the fishermen out of Pennsville ever were paid back their twenty-five dollar fines.

## And the Winner is…

Occasionally, sports writers and historians talk about some contest as being the sporting event "of the century." In July 1876, when the nation was celebrating

the centennial of our nation's founding, a prizefight occurred in Pennsville that some might argue qualifies for that designation. On July 28 of that year, fight promoters from Philadelphia, who had been made to feel unwelcome by the City of Brotherly Love, got permission to stage a fight between John Kennan (age eighteen and 118 pounds) and James Collins (age twenty and 116 pounds) on Brandriff's Beach. They battled each other for ninety-four rounds.

Joseph Sickler, in his book *The History of Salem County*, described the outcome:

> *In the ninety-fourth round, Kennan pushed Collins to his corner and he fell without a blow. Then his seconds threw up the sponge. Thus ended the longest fight in New Jersey ring history. The police made no attempt to stop the fight although it was openly in defiance of the statutes at that time. The press of the day openly admitted that the police at Pennsville were afraid of the blood-thirsty crowd and probably they had good reason to be. The newspaper expressed the hope that if any more gamblers, prize fighters and cut-throats assembled at Pennsville again, they would receive a dose of Jersey justice that would convince them that they could not break the laws with impunity. Kennan, fort all his services rendered in drubbing Collins, received the princely sum of one hundred and fifty dollars. Collins received the aforementioned beating.*

# Robert Brooks Remembers

When, thirty-seven years ago, Robert Brooks of Woodstown took his place as a research chemist in DuPont's Jackson Laboratory in DuPont's Chambers Works along the Delaware River north of what is now the I-95 Bridge, the lab was the largest and perhaps most respected research laboratory in all of America (see Chapter 9). Brooks started working with neoprene—synthetic rubber. "In a way," he said with a smile, "I was researching anything that, when stretched, snapped back." Technically, his research was in the areas the Jackson Laboratory and the DuPont Company were especially noted for internationally: dyes and chemicals. Eventually he became manager of the Jackson Laboratory. As such, he was responsible for helping to create the space and conditions in which other researchers conducted their experiments. "For example, I was responsible for creating safe conditions for and offering encouragement to such researchers as Charles Pedersen." Pedersen, who later became Brooks' father-in-law, won the Nobel Prize for his work (see Shirley Brooks Remembers).

# DuPont Ignites Boom Times

Robert Brooks stands in front of a window in his study that depicts the crown ethers that were the subject of the research by Charles Pedersen.

Most of the chemists engaged in research at the Jackson Laboratory had earned their doctorate, said Brooks, but there were some researchers who did not have theirs. One such researcher was a man from Switzerland. "One day, another research chemist came up to me to complain that he was asked—and resented—a question by the man from Switzerland who 'doesn't have a doctor's degree.' In other words, this man was saying that no one should ask a question of someone with a doctorate unless he also has one."

At the time when Brooks worked at the Jackson Laboratory, DuPont was still producing dyes used in products such as Teflon, nylon and a number of other products, "but I was most involved with refrigerants and related products, particularly Freon." A trademark product from DuPont, Freon was a nonflammable, gaseous, fluorinated hydrocarbon used mainly in refrigeration and air conditioning and also as an aerosol. It has nearly disappeared because of the ozone depletion problem, Brooks said.

> *The business* [of inventing and manufacturing products like Freon] *was a fascinating business to be in. In the dye business, if you came up with a new dye, DuPont might make ten thousand pounds of the dye. On the other hand, in the case of Freon, DuPont might produce*

*millions of pounds. Products like Freon could put a lot of money in the bank* [for DuPont].

"DuPont was a great company to work for," said Brooks. At one point in his long career at DuPont, he was asked to come to the main headquarters of DuPont in Wilmington. He was among those people DuPont called on to discuss the company's dye works and to advise management as to whether it should continue what it was doing in that area. "At the time, I and others advised management to keep an eye on the dye works. It required a tremendous new investment." For one thing, Brooks said, during World War II, American and British bombers pretty much destroyed the old dye works plants in Germany, where dye works had originated, but after the war, Germany built new plants that now competed with DuPont operations. "We blew off Germany's nineteenth century dye works and they built new twentieth century plants. We [Du Pont] still had the nineteenth century dye plants and the mind set that went with it. So, we were losing ground to the Germans, and the Japanese also were getting into dye works." At one point, Brooks became the technical director of the Dyes and Chemicals Division and then technical director of the Freon Division.

## Role of Research

Speaking of research, Brooks said, it is one thing to come with a lot of great ideas, but if they sit on a shelf somewhere and never get put to some good end, then the research hasn't accomplished much. The best one can say about research, he continued, is that "if you didn't have this [what research proved or developed] you couldn't have that [a product of benefit to mankind]. For example, Brooks said, the jet engine was probably invented at the time of Jesus Christ or before by the ancient Greeks, but it was considered a toy. They didn't have the materials and such to make something of it. Actually, it was a steam generator, the steam blowing out of a jet. The jet was mounted so it could rotate. "We used to have one of these in the lab. Someone had made it in school. It could go at tremendous speeds. It had never occurred to the Greeks that they could drive something with their steam jet, something like an airplane."

Part of the Greeks' problem, Brooks said, was technical; the other part was mental. People [then] were not trying to make advances of that sort [weren't interested in inventing a new process or new equipment].

"The purpose of the Jackson lab was to take ideas and put them to work."

# SHIRLEY BROOKS REMEMBERS

For the first eleven years of her life, Shirley Brooks lived in DuPont Company housing in Carney's Point. All the two-story houses on her street looked alike, and each one was occupied by a DuPont chemist and his family. "As far as I know or remember," said Mrs. Brooks, "none of the chemists living in those houses were originally from Salem County. They came from all over the United States to work at DuPont." The street she and her family lived on was called Delaware Avenue; it is now Jefferson Street. On the next block, she said, were the typical green bungalows owned by DuPont. Hourly workers and their families lived in the bungalows.

*As a kid, I never really knew the difference between our house and the bungalows, but my mother told me later that you could tell whether your husband [or father] had a better job than somebody else by what happened when a house became vacant because someone may have been transferred. People would put their name in to get that house, and the person [employee] with the highest ranking in the company would have first dibs on the house.*

Shirley Brooks looks over the scrapbook pictures of the ceremony when her stepfather, Charles Pedersen, received the 1987 Nobel Prize in chemistry. She holds the prize medal.

Charles Pedersen is awarded the Nobel Prize in chemistry.

*My mother said some people would put their name in just to find out if their husband was higher up in the ranking than someone else.*

In 1947, Mrs. Brooks's father and mother divorced, and she and her mother moved into a house on Market Street in Salem city. Her mother later married Charles J. Pedersen, also a DuPont research chemist. Pedersen's mother was Japanese and his father Norwegian, and he was born in Korea. His father had worked in a gold mine in Korea. After Mrs. Brooks's mother married Pedersen, the family remained in that house until 1989. Pedersen initially researched petroleum additives, and as a result, he could claim more than sixty patents. Perhaps the most important of the patents, said Mrs. Brooks, was one for tetra-ethyl lead. "Without tetra-ethyl lead, we might not have won World War II," said Robert Brooks, her husband and retired DuPont chemist. "Tetra-ethyl lead raised the octane rating of gasoline." Pedersen's work with petroleum additives eventually led to his research and discovery regarding crown ethers, for which he won the 1987 Nobel Prize in chemistry.

## Growing Up with a Genius

"My stepfather never thought of himself as a genius," said Mrs. Brooks.

> *He was the epitome of being a gentleman. He was a wonderful step-father and husband to my mother. He told me one time that he would have been an artist or poet if he could have made a living that way. He figured he had to do something to make a living, and the thing he liked about chemistry was the beauty of it. He saw the beauty of art in the beauty of chemistry.*

Pedersen had graduated from Dayton University in Ohio and earned a master's degree at MIT. His professors at MIT urged him to continue on and earn his doctorate. "But he figured at that point that his father had supported him long enough," said Mrs. Brooks, "and he decided it was time for him to go to work." He went to work for DuPont. According to Mrs. Brooks, Pedersen had always been a family friend, from the time she was a child. Both he and her father were chemists. "I can't remember a time when I didn't know him," she said.

When asked what it was like living with a genius, Mrs. Brooks said the family led a pretty normal life—at least up to the time he was being considered for and then awarded the Nobel Prize in chemistry. However, she said, after her mother died and her stepfather was in poor health, the person who took care of him said that being with Pedersen was like being with a walking and talking encyclopedia. "However, one thing about my father was that he was interested in other people," she said.

> *I can remember one year at Easter when one of my daughters was dating someone who was working as an exterminator. Our entire Easter dinner conversation was my stepfather asking my daughter what one did about wasps and ants and such. He was genuinely interested in people. When he found out something about somebody, he asked a lot of questions. He was always curious, but he also was very naïve. For example, if he read something in the paper or saw something on TV, he was sure it had to be true because it had been published or broadcast.*

One might suspect that dinner conversations in a household where a member of the family spent his day in deep research could be dull. Not so, said Ms. Brooks.

*We ate dinner together every night. I might have come from basketball practice. I can't remember a time when he talked about his work. He loved his garden and spent a lot of time out there. As I said before, he loved beauty. He wrote a lot of poetry. After he died, my sister and I were going through the house and found all kinds of poetry. He often would write poetry when something was upsetting him. He really loved Salem. After dinner, he and my mother often would walk around town.*

What surprised many people about Pedersen was how he was interested in so many things and how interesting he was. Robert Brooks, who said he had been privileged to know a couple of Nobel Prize winners, believes most people think such geniuses are single minded and cannot speak with other people about subjects unrelated to their research. "On the contrary, these geniuses are people with a lot of interests. I remember being in the home of Melvin Calvin, another Nobel Prize winner, and when his children started playing with a new toy on the floor, he got down on the rug with them, and together they tried to figure out how the thing worked." Pedersen loved the games Trivial Pursuit and Jeopardy, said Mrs. Brooks; except, when playing Jeopardy, he couldn't always come up with the answer before the bell. "One of the funny things about my stepfather was that when someone would ask him a question, he would go on and on with his answer, giving all this information; then when he was all done, he would say, 'I think.'"

## *Winning the Nobel Prize*

Everything connected with the Nobel Prize ceremony was organized in every detail, said Mrs. Brooks. "Of course, what pleased me most was when my stepfather gave his acceptance speech and he began by saying, 'I bring you greetings from Salem County, New Jersey.'" Mrs. Brooks and her sister were seated in the front row center for the awards ceremony. Sweden's king and queen were in attendance, and Mrs. Brooks and other family members met them. "My stepfather and the queen hit it off so well, and when she came over to Delaware the next year and we were in the reception line, she recognized Charlie and said, 'I remember you,' and then she looked at me and said, 'and I remember you, too.'"

When Pedersen and his family returned to Salem, the city had strung a banner across Market Street in his honor. Later, schoolchildren came to the house to talk with him, even though he was in failing health. "Often, he would ask the children questions," said Mrs. Brooks, "questions about what

they wanted to do with their life. Depending on their answer, he might say, 'Did you ever think of doing this or that?'"

Pederson, who never earned a doctorate because he didn't think he should ask his father to spend more money on his education, refused later in life all offers from universities that wanted to award him an honorary doctorate. His stepdaughter said, "He wanted to prove to people that someone who hasn't earned a doctorate is still capable of doing good work."

# Preserving Today for Tomorrow

Just a few years ago, the housing developments and malls that had obliterated most of the farms in Gloucester County to the north seemed perched on the Salem County boundary ready to invade. Then the economy soured, and the invasion was halted, perhaps temporarily unless dedicated and determined landowners continue to preserve the rich farmland that has been labeled—at least by longtime farmer and freeholder Lee Ware—the Garden Spot of the Garden State.

"I'd like to see farmland continue to be here for future generations," said Sam DiGregorio, whose sixty-acre farm in Carneys Point was preserved in a ceremony this past April; "it's a little part of our county's history." A little part? Farmland and what takes place on it have been a huge part of Salem County history. You can't talk about Lenape Indian women planting corn on stream banks, Revolutionary War foraging parties or feeding the new nation without talking about farming and farmers in Salem County.

The county's farmers and the state of New Jersey have recognized the critical importance of Salem farms and farmers. More farm acreage has been preserved in Salem than in any other county in the state—28,000-plus acres as of last spring (2011). Throughout the state, 190,000 acres had been preserved up to that time. At the same ceremony where DiGregorio's acreage was preserved, 78 acres owned by the Yetneck family also were preserved. "It's something I've always wanted," said Rosemary Yetnik. "It's so important for the farm to continue on."

# In the Beginning

The state Department of Agriculture launched the Farmland Preservation Program in 1985 because "farmland preservation clearly is an important investment in our economy, our farming heritage and the overall quality of life of each and every New Jerseyan." One of the first farms in Salem County to get on board with the preservation program was owned and operated by Harry and Edwin Paulding of Pilesgrove Township. They preserved 207 acres east of Woodstown-Daretown Road and bordering Renter Road in 1992. When asked how old they were when they first started farming those acres, Harry Paulding replied, "When we were born, I guess." He explained that the brothers, having been born into a farming family eighty-plus years ago, were expected to become farmers and eventually to take over running the farm. The brothers started working on the farm "as soon as they could lift something," said Clair Paulding, Harry's wife. At the time, the farm raised dairy cows and grew hay, corn and wheat. In 1975, the brothers sold the dairy cows and bought cattle, approximately ninety head, which they sold for beef. They also grew some soybeans, tomatoes and potatoes.

Harry said:

> *We got interested in preserving our farmland when we looked north and saw what was happening around Swedesboro. We thought we'd like to keep our farmland down here. What really started us thinking was when we got to talking with our neighbor, Mister Mosley on Renter Road, who had just moved into the area and decided to preserve his land. That was in '89 when we first started thinking and talking about preservation.*

While Harry Paulding has retired from farming, he still "likes agriculture" and has been working as a groundskeeper for the Salem County Fairgrounds. "I'm still involved in keeping things going some." Also, the Paulding brothers still own seventeen acres on which their homes are located and where they still tend gardens. Eventually the brothers want to preserve the seventeen acres as well. Two Paulding sons also live in houses on the seventeen acres, but they do not farm.

# Preserving Farming Families

Last April, the 102-acre farm in Mannington Township owned by Ernest Tark Jr. and his sister, Maxine Rauch, became the 2,000th farm preserved

in New Jersey. Tark's farm on Quaker Neck Road is defined as a class-one farm. "The reference is to land," said Tark.

*Land is divided into five classes, with one and two classes being the best. Class-one and -two lands have the proper amount of organic compounds, the best soil and the best drainage. They are the farms you need to produce food for the next generations. I firmly believe that class one and two lands should never be built on.*

Unfortunately, said Tark, who is deputy mayor of Mannington Township, class-one and -two lands also are the best to build houses on because of very good drainage. So, builders would rather build on class one and two lands for that reason. According to Tark, Mannington Township has a high percentage of class-one and -two lands that have been farmed going back to the American Revolution and before.

Tark came to Salem County in 1965 from Monmouth County, where his family's farm became included in the state's Green Acres program because it adjoined the Monmouth Battlefield, where a key battle of the American Revolution took place. Tark once farmed 600 acres, 400 in Mannington and 200 in Quinton Township. "I still own 130 acres in Quinton, which have been entered in the state's program but have not yet been preserved."

Almost 40 percent of Mannington Township farmland is preserved, said Tark, "so the future for agriculture here is pretty good." Also, unlike in some areas of Salem County and elsewhere in New Jersey, where the average age of today's farmer is sixty-plus, in Mannington Township, the average age of the farmer is thirty-five to forty-five," said Tark. "I think there are some young farmers elsewhere in the county, too."

Tark is convinced that the farms of Salem County have a reasonably bright future: "You know, we are in the heart of the largest metropolitan area in the country. It runs from Maine to Richmond, Virginia. So, because we're in the middle of it, the fresh market [mainly through the Vineland Auction] for Salem farmers is good going north and south."

# CLOSE CALL

When, early in 2010, Frank Fichera preserved his 476-acre farm in Mannington Township, Michele Byers, executive director of the New Jersey Conservation Foundation, reminded Salem County that such farmland

preservation efforts have helped to ensure the major role agriculture plays in the county and state. But she warned the county to be on guard when it comes to preserving its farmland. In 2006, she said, a major developer (not named) had hopes and plans to build three thousand homes in the Mannington Meadows. They did not materialize—then.

# Bibliography

*Alloway Remembers.* 2nd ed. Alloway, NJ: Alloway Township Bicentennial of the Constitution Committee, 1988.

Beckett, Grace. "An Historical Study of Agriculture in the Seven Southern Counties of New Jersey from Early to Recent Times." Master's thesis, Glassboro State College, 1937.

Camp, Latitia Duell. *Days on the Farm.* Self-published, 2009.

*Carney Pointer,* May and June 1946.

Cunningham, John T. *Garden State.* New Brunswick, NJ: Rutgers University Press, 1955.

————. *This New Jersey.* New Brunswick, NJ: Rutgers University Press, 1978.

Cushing, Thomas, and Charles E. Sheppard. *History of the Counties of Gloucester, Salem and Cumberland New Jersey.* Everts & Peck, 1883.

*Hires Turner: A Century in Glass.* Hires Turner Glass Company, 1963.

*The History of Mannington Mills: 1915–2000.* Mannington Mills.

Kinnane, Adrian, *DuPont: From the Banks of the Brandywine to Miracles of Science.* E.I. duPont de Nemours Company, 2002.

Miller, Neil C. "The DuPonts and Smokeless Powder for France During World War I." N.p., 1973.

Parker, John Everett. "Farming in Southern New Jersey: 250 Years of Environmental Change." Master's thesis, Glassboro State College, Glassboro, New Jersey, 1975.

*Salem Quarter, the Salem Quakers Quarterly Meeting, Southern New Jersey 1675–1990.*

Sheridan, Janet L. Survey and Documentation of Marshalltown, 2010. Salem County Historical Society, Salem, New Jersey.

Sickler, Joseph F. *The History of Salem County New Jersey.* Salem, NJ: Sunbeam Publishing Company, 1937.

Sim, Mary B. *History of Commercial Canning in New Jersey: History and Early Development.* Trenton, NJ: New Jersey Agricultural Society, 1951.

Smith, Andrew F. *Souper Tomatoes: The Story of America's Favorite Food.* New Brunswick, NJ: Rutgers University Press, 2000.

Woodward, Carl Raymond. *Ploughs and Politicks: Charles Read of New Jersey and His Notes on Agriculture: 1715–1774.* New Brunswick, NJ: Rutgers University Press, 1941.

# About the Author

Charles H. Harrison is a longtime resident of Salem County. He and his wife, Charlotte, live in a 160-year-old house in Woodstown. He has written previously about New Jersey and Salem County history. His books include *Salem County: A Story of People, Growing a Global Village: the Story of Seabrook Farms* and *Tending the Garden State*. He also has written a number of newspaper and magazine articles.

Visit us at
www.historypress.net